MW00634544

IMAGES
of America

ROMAN CATHOLIC DIOCESE OF PITTSBURGH

On the cover: In this 1934 photograph, the children of St. Peter Parish on the South Side honor the Blessed Mother in a solemn May Crowning ceremony. St. Peter Parish was founded in 1871 in response to the growing German population in this Pittsburgh neighborhood. (Courtesy Diocese of Pittsburgh Archives.)

IMAGES
of America

ROMAN CATHOLIC DIOCESE
OF PITTSBURGH

Mary Ann Knochel

ARCADIA
PUBLISHING

Copyright © 2007 by Mary Ann Knochel
ISBN 978-0-7385-4963-7

Published by Arcadia Publishing
Charleston SC, Chicago IL, Portsmouth NH, San Francisco CA

Printed in the United States of America

Library of Congress Catalog Card Number: 2006935747

For all general information contact Arcadia Publishing at:
Telephone 843-853-2070
Fax 843-853-0044
E-mail sales@arcadiapublishing.com
For customer service and orders:
Toll-Free 1-888-313-2665

Visit us on the Internet at www.arcadiapublishing.com

CONTENTS

ACKNOWLEDGMENTS

This book would not have been possible without the guidance of Ken White, director, and Burris Esplen, archivist, at the Archives and Records Center of the Catholic Diocese of Pittsburgh. Without their permission, the majority of the images in this book would not have been included. I am forever grateful. And certainly, those who came before us and brought with them a beautiful and rich Catholic tradition that they handed down to new generations are to be remembered and acknowledged for their courage, steadfastness, and unwavering Catholic faith.

INTRODUCTION

There have been myriad volumes written about the history, theology, and traditions of the Roman Catholic Church. Many were written by divinely inspired saints and theologians, scholars, clergy, and learned laypersons. This author cannot hold that proverbial candle to any of those who came before us and motivated us to know more about our faith.

This book is simply intended to be both a literal and figurative snapshot of the people who shaped and influenced, whether by word or deed, the growth of the Roman Catholic Church in Southwestern Pennsylvania during the 19th and 20th centuries. Émigrés from Central and Eastern Europe settled in this region for many reasons, not the least of which was the topography that mirrored that of their homelands. They felt comfortable here; there were other groups already settled here who spoke the same language and shared the same customs and traditions. An important commonality among all immigrant groups was their strong Catholic faith. Many examples exist of immigrants settling in a region and, before any other needs are addressed, a church is built. That a priest may not have been available did not discourage these determined Catholics; the church served as a common house of prayer, a gathering place, a center where faith could be shared.

Southwestern Pennsylvania is undeniably an ethnic region that is made up of people from diverse backgrounds who still maintain the traditions handed down through generations of strong, proud immigrants who made the arduous trip across the Atlantic to settle in an unknown, and occasionally hostile, region. People are proud of their traditions and their ethnic backgrounds, and each ethnicity has contributed much to the Catholic Church in this region. We dedicate our churches to saints who have set an example of enduring faith. We still refer to our communities according to the names given them by those who settled there: Deutschtown, Polish Hill, Little Italy.

The Catholic Church in this region did not grow in a vacuum. An amalgamation of politics, religion, and industry had a major influence on the development of the region. Catholics played a significant role in the history of this six-county diocese. While researching my own genealogy, I discovered what their faith must have meant to my ancestors, and how important it was to pass it down to a new generation of Americans. Not every parish or school is represented herein; those that are included, however, are representative of the Catholic immigrant experience. I learned a lot, and at times was surprised by what I learned. It is my hope that those who hold their Catholic faith dear to their hearts and those who are interested in the political and industrial history of Pittsburgh can find something in this book that surprises them, too.

One

PITTSBURGH AND ALLEGHENY CITY

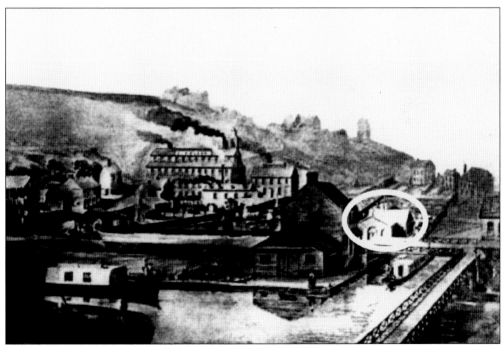

This 1850 drawing is the first known depiction of Pittsburgh's first Catholic church (circled), located at the footbridge to the Pennsylvania Canal at Liberty and Washington Streets, Strip District. With only 20 Catholic families in the city, St. Patrick was dedicated in 1811. Plans for pews were drawn on the floor and, as they could afford it, families would hire a carpenter to build their pew on their chosen site. (Courtesy St. Patrick-St. Stanislaus Kostka Parish Archives.)

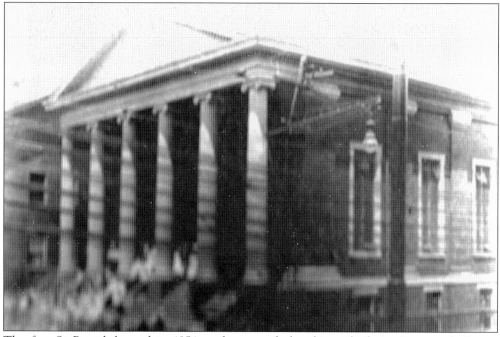

The first St. Patrick burned in 1854, and a second church was built on Fourteenth Street. The second St. Patrick could not accommodate the growing population brought about by the Civil War. The property was sold to the Pennsylvania Railroad Company, and the church was demolished. Seen in this 1911 image is the third St. Patrick at Seventeenth Street and Liberty Avenue. It was dedicated in 1865. (Courtesy Diocesan Archives.)

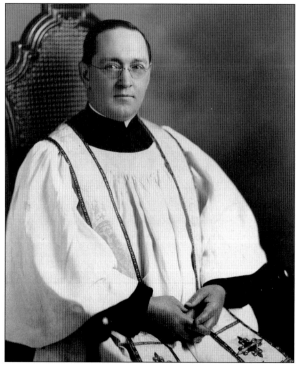

By 1923, the future of St. Patrick was in doubt. Only 35 Catholic families remained in the city, others having been pushed out by burgeoning industry. That year saw the arrival of a new pastor, Rev. James P. Cox, shown in this c. 1920s image. Born in 1886 in Lawrenceville, the son of a Methodist father and Catholic mother, Father Cox dramatically revitalized the parish. (Courtesy Diocesan Archives.)

Father Cox grew up during an era of rapid industrial expansion. Working his way through Duquesne University as a cab driver and a steelworker, Cox experienced firsthand the plight of the working man. After graduating St. Vincent Seminary in Latrobe, he was ordained in 1911. From 1917 to 1919, he served in World War I, after which he enrolled in the University of Pittsburgh, earning a master of economics degree. (Courtesy Diocesan Archives.)

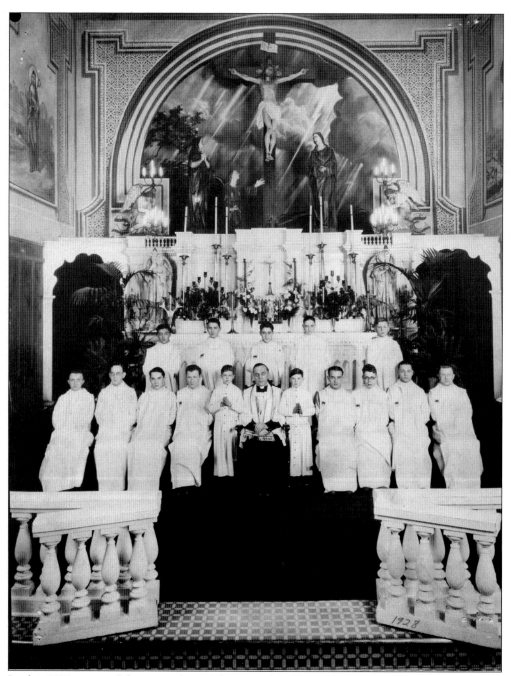

In this 1928 image of the main altar of the second St. Patrick, assistant pastor Rev. Andrew J. Zapora is seated in the first row center. By this time, St. Patrick had become known as the "American Shrine to Our Lady of Lourdes," in appreciation for the healing of Fr. James Cox's eyes at Lourdes, France. (Courtesy St. Patrick-St. Stanislaus Kostka Parish Archives.)

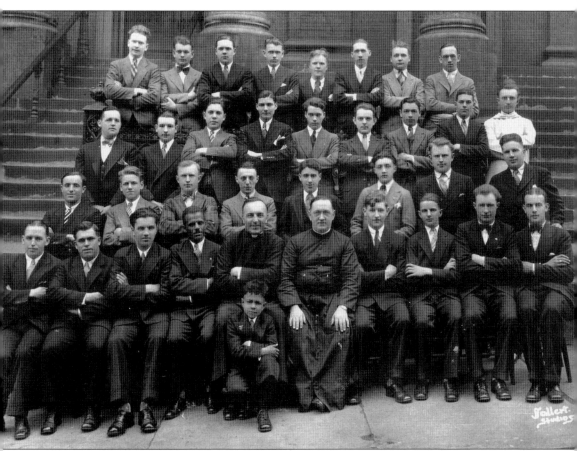

Father Cox (bottom row, center) sits on the steps of St. Patrick with the Young Men's Guild in this 1929 image. Beginning in 1925, a local radio station began broadcasting the daily Mass from St. Patrick, a practice that lasted for 33 years. (Courtesy St. Patrick-St. Stanislaus Kostka Parish Archives.)

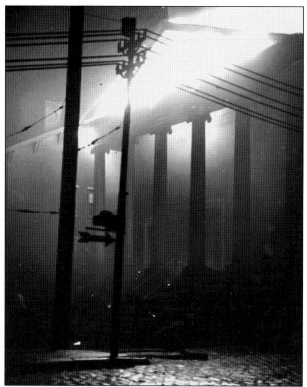

On March 21, 1935, St. Patrick was destroyed by fire. While a new church was being built, Mass was celebrated in the Good Samaritan Chapel. The new (fourth) St. Patrick was dedicated on March 17, 1936. (Courtesy St. Patrick-St. Stanislaus Kostka Parish archives.)

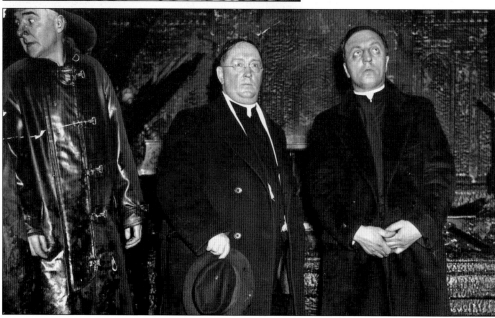

Rev. James Cox (center) and assistant pastor Rev. Andrew Zapora look on and pray as St. Patrick burns. An unidentified City of Pittsburgh fireman stands to the left. St Patrick was no stranger to misfortune. In 1894, flames from an adjacent machine shop spread to the church and destroyed it. It was then that the site for the third St. Patrick was moved to Fourteenth Street. (Courtesy St. Patrick-St. Stanislaus Kostka Parish archives.)

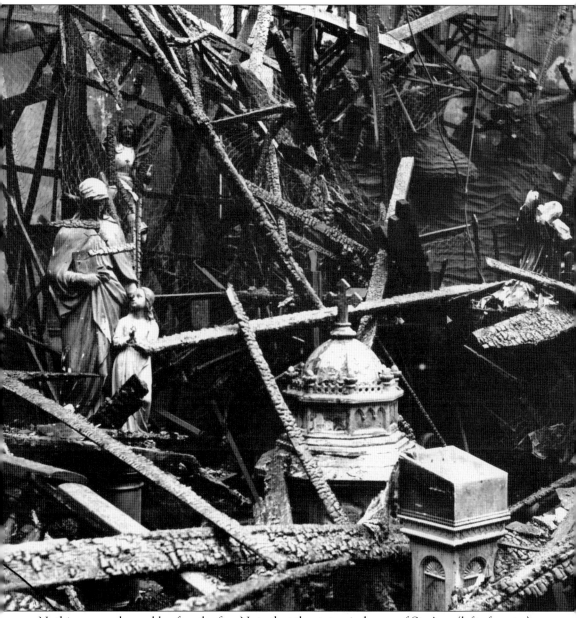

Nothing was salvageable after the fire. Note that the statue in honor of St. Ann (left of center), however, appears to be relatively untouched. (Courtesy St. Patrick-St. Stanislaus Kostka Parish archives.)

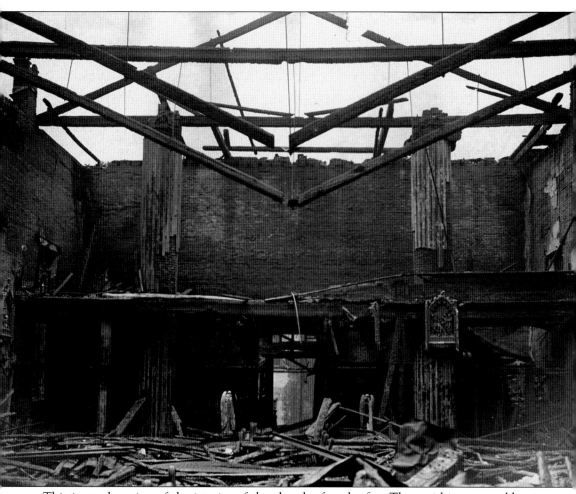

This is another view of the interior of the church after the fire. The parishioners would not mourn their loss for long. Plans to rebuild were begun almost immediately. Within a year, they would celebrate the completion of a new church dedicated to St. Patrick that would last until the population decline of the late 20th century. (Courtesy St. Patrick-St. Stanislaus Kostka Parish archives.)

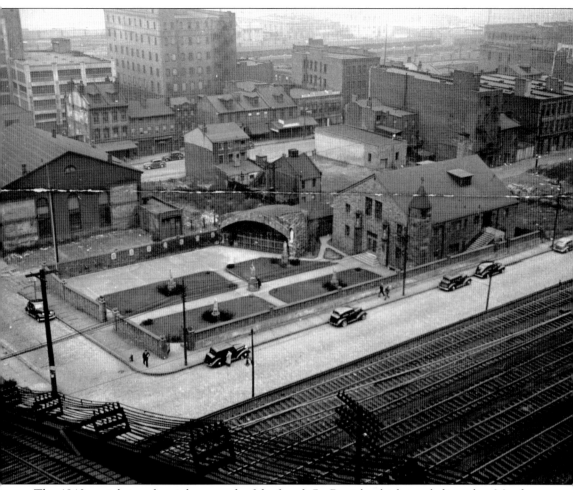

This 1940s aerial view shows the grounds of the fourth St. Patrick, which was dedicated on March 17, 1936. The grotto and monastery gardens were added in 1937. The grotto included a marble altar, upon which outdoor Masses were celebrated in good weather. A piece of the Blarney Stone from Blarney Castle in Ireland was placed in the tower that sheltered the baptistry. (Courtesy Diocesan Archives.)

During the Great Depression, St. Patrick became a center for relief of the poor, distributing over two million free meals and 500,000 baskets of food, clothing, and fuel—all under the direction of Fr. James Cox. Shantytowns, or Hoovervilles, sprung up in the shadow of the church and were populated by jobless men who constructed a community out of any salvageable material. (Courtesy St. Patrick-St.Stanislaus Kostka Parish archives.)

Known as Pittsburgh's "Pastor of the Poor," Fr. James Cox led a march of 25,000 unemployed Pennsylvanians to Washington, D.C., hoping to spur Congress into starting a public works program. Pres. Herbert Hoover, suspicious that Father Cox was financed by the Vatican or Democratic supporters of Al Smith, launched a full-scale investigation. President Hoover found that Secretary of State Andrew Mellon had quietly ordered his Gulf Oil gas stations to dispense free gas to the marchers. This proved to be the pretext for Hoover to remove Mellon from his post. (Courtesy St. Patrick-St. Stanislaus Kostka Parish archives.)

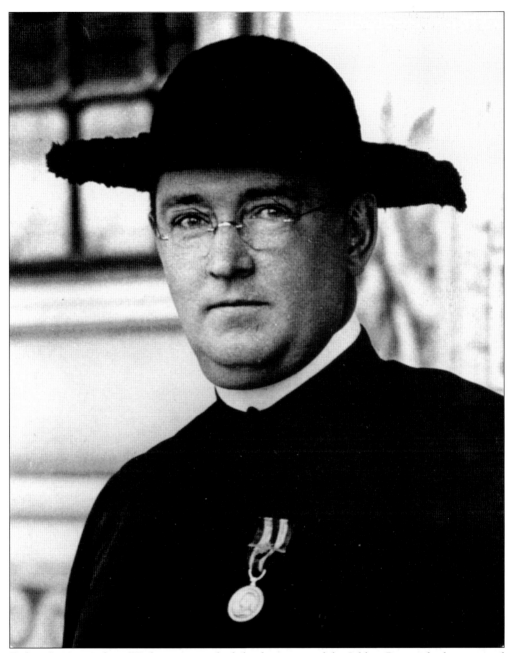

Father Cox's march to Washington sparked the formation of the Jobless Party, which supported government public works and labor unions and eventually spread from Pittsburgh to other major cities. Father Cox became the party's first presidential candidate. In 1932, Father Cox pulled out of the election, giving his support to Franklin Delano Roosevelt. After the election, Father Cox continued his relief work and was a member of the Pennsylvania Commission for the Unemployed. In the mid-1930s, Roosevelt appointed him to the state recovery board of the National Recovery Administration. Father Cox was a mentor to Fr. Charles Owens Rice, who would inherit his mantle as Pittsburgh's labor priest for the rest of the 20th century. (Courtesy Diocesan Archives.)

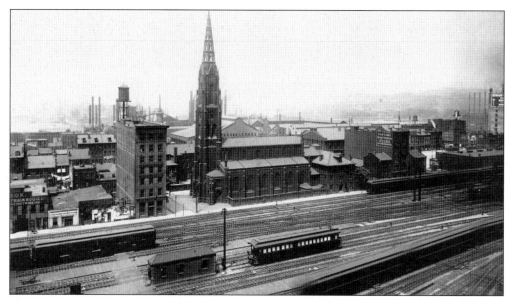

The first German ethnic church in the diocese was St. Philomena, founded in 1839 in the Strip District. The church lay in the center of industry among steel mills, glass factories, and the railroad. In this 1917 image, the church's 225-foot cast-iron spire can be seen pointing to the Heavens. The tower became known as the "tower of fire" because flames and sparks from the mills behind illuminated it at night. (Courtesy Diocesan Archives.)

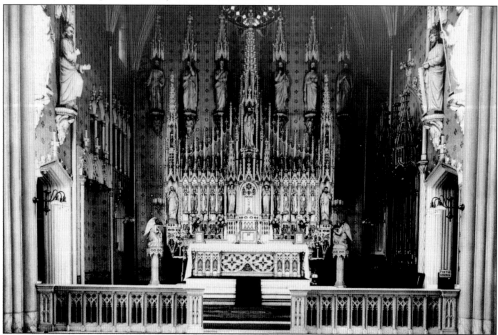

This main altar of St. Philomena was constructed in the ornate Gothic style that was typical of the time. Because of the growing commercialization of the Strip District over time, St. Philomena was no longer viable in its original location. On April 15, 1922, the church was sold to the Pennsylvania Railroad. The last Mass celebrated on this altar was on November 16, 1925. (Courtesy Diocesan Archives.)

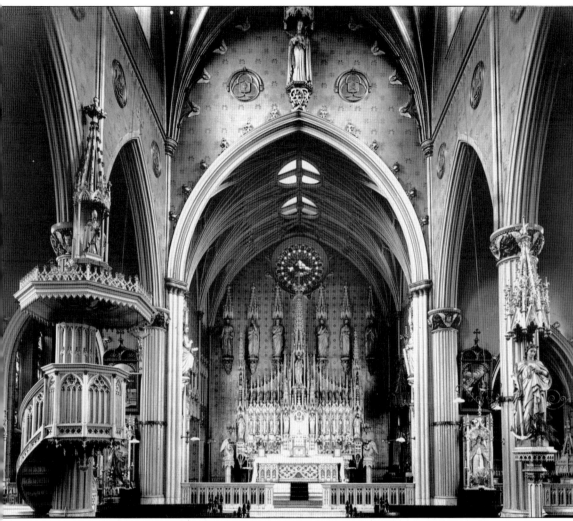

This c. 1917 image of the interior of St. Philomena clearly shows the awe-inspiring beauty of this Gothic-style church, which turns one's thoughts and prayers heavenward. At the time, parishioners were temporarily transported from the noise, pollution, and dirt of the city to a quiet place that inspired calm and prayer. (Courtesy Diocesan Archives.)

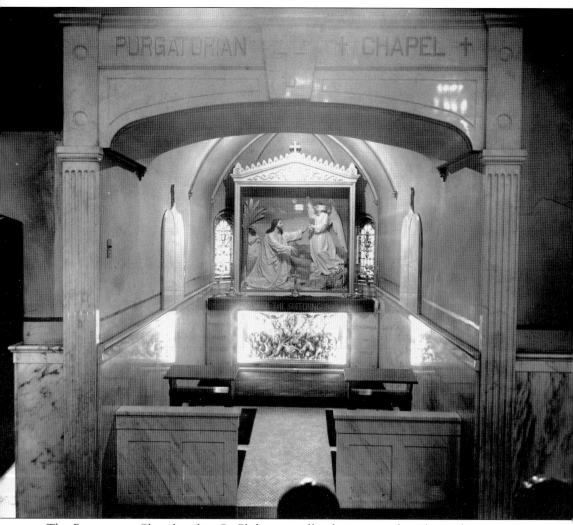

The Puragtorian Chapel within St. Philomena offered a private place for meditation, prayer, and reflection. Redemptorist priest Blessed Francis Xavier Seelos served the parishioners at St. Philomena for nine years, first as assistant to St. John Neumann and the last three as pastor. He particularly loved the poor, and it has been said that if he saw a man without shoes, he would relinquish his own, returning to the church in stocking feet. (Courtesy Diocesan Archives.)

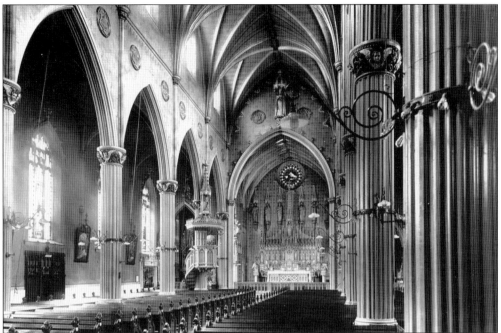

This c. 1917 view of St. Philomena's main aisle demonstrates the grandeur of the architecture and elicits appreciation for the many artisans who constructed the building. Redemptorist priest (now a saint) John Neumann carried out his pastoral duties to the more than 6,000 German Catholics in Pittsburgh at that time. During his years in Pittsburgh, Father Neumann wrote two catechisms, both in German and English. (Courtesy Diocesan Archives.)

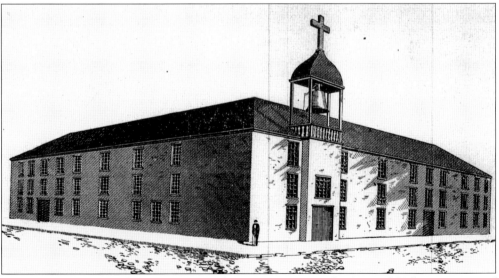

While the second St. Philomena was under construction in the Squirrel Hill community of Pittsburgh, parishioners attended Mass in an industrial building located on Spring Alley and Fourteenth Street, referred to at the time as the "Factory Church." Father Neumann struggled to solve the financial difficulties of the parish while overseeing the construction of a new church. When St. Philomena was dedicated in 1846, it was said that he accomplished the impossible and built a church without money. (Courtesy St. Patrick-St. Stanislaus Kostka Parish Archives.)

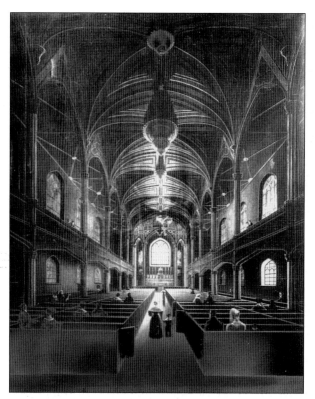

This *c.* 1840 drawing depicts the interior of the first St. Paul Cathedral, founded in 1834 on the corner of Grant Street and Fifth Avenue in downtown Pittsburgh. The congregation was not wealthy; fund-raising was slow. The church was not ready for occupancy until 1834. In 1844 and again in 1847, the city lowered the grade of the hill on which St. Paul Cathedral sat. The church towered 30 feet over the surrounding streets, and the foundation was undermined. Before the situation could be remedied, a fire destroyed the church in 1851. (Courtesy Diocesan Archives.)

As occurred with other parishes within the city of Pittsburgh, population growth and business expansion made it necessary to move the cathedral. A lot was purchased on the corner of Fifth Avenue and Craig Street in the Oakland section of Pittsburgh, and the cornerstone for the third St. Paul Cathedral was laid in 1903. Construction was completed in 1906. (Courtesy Diocesan Archives.)

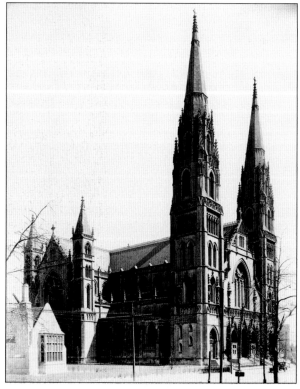

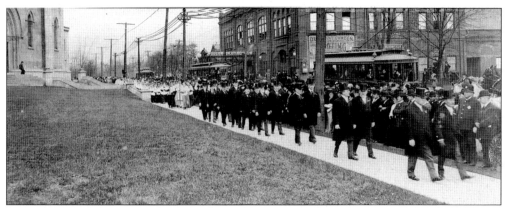

St. Paul Cathedral was completely paid for when it was dedicated in 1906 and included a pipe organ donated by Andrew Carnegie. In this image from 1906, it can be seen that the dedication was a time for celebration; dignitaries, clergy, and the faithful participate in a procession past the new cathedral. In 2006, renovation and repair to the church began in preparation for the centenary celebration. (Courtesy Diocesan Archives.)

Rev. Coleman Gasparih was the first pastor of St. Elizabeth of Hungary Parish. This photograph was taken in Sarajevo in 1895, shortly before Father Gasparih was assigned to St. Elizabeth of Hungary, a result of petitioning by the parishioners. The church was established in the Strip District in 1895 and was the first Slovak church in Pittsburgh. (Courtesy Diocesan Archives.)

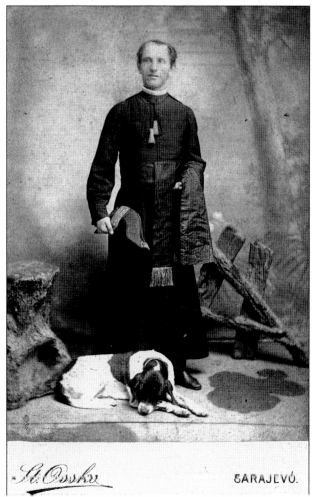

SARAJEVÓ.

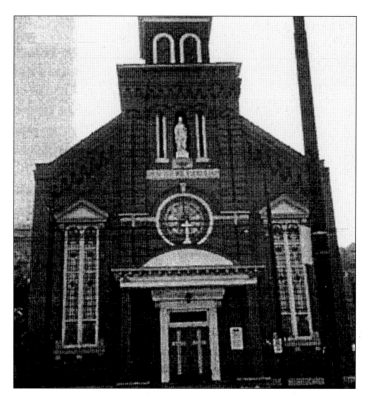

St. Elizabeth of Hungary was established in the Strip District in 1895 and was the first Slovak church in Pittsburgh and the second Slovak church in the diocese. This 1970 image shows the exterior view. The United States Post Office purchased the property on which St. Elizabeth of Hungary sat, and a new church was built at 1620 Penn Avenue. The parish merged with St. Patrick and St. Stanislaus Kostka in 1993. (Courtesy St. Patrick-St. Stanislaus Kostka Parish archives.)

Established in 1875 in Pittsburgh's Strip District, St. Stanislaus Kostka was the diocese's first Polish parish. This 1937 image depicts the church that was dedicated in 1892. In 1936, the church survived, albeit with significant damage, the great flood in Pittsburgh. The water level rose to a point where the pews were literally afloat. Additional damage occurred in December 1936 from an explosion in the nearby Pittsburgh Banana Company. The towers experienced significant damage and were subsequently lowered. (Courtesy St. Patrick-St. Stanislaus Kostka Parish archives.)

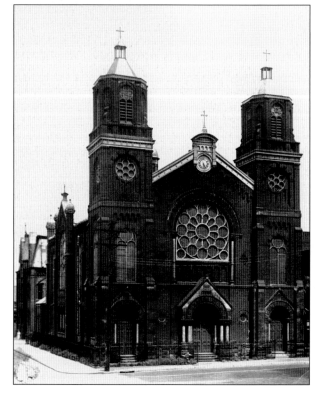

In 1887, St. Stanislaus Kostka Parish purchased land to build a church and a school. The school, seen here in an undated photograph, was dedicated on April 15, 1888. A space on the third floor was used as a temporary church. The first Mass was celebrated there on April 21, 1888. (Courtesy St. Patrick-St. Stanislaus Kostka Parish archives.)

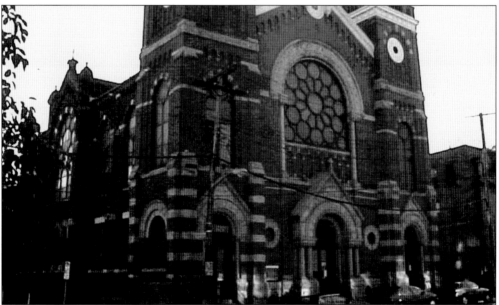

The latter half of the 20th century witnessed a dwindling population in the city, and it was no longer feasible to support three parishes in the Strip District. In 1993, St. Patrick, St. Elizabeth of Hungary, and St. Stanislaus Kostka parishes merged to form St. Patrick-St. Stanislaus Kostka Parish. The congregation worships in the former St. Stanislaus Kostka church, as seen in the 2002 photograph. Note that the towers were not replaced after the 1936 explosion at the Pittsburgh Banana Company. (Courtesy Diocesan Archives.)

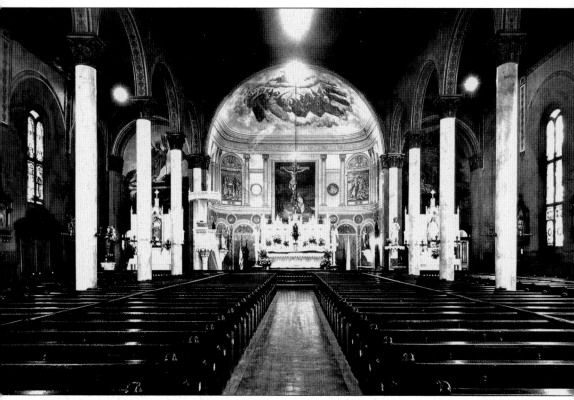

St. Brigid was founded in 1853 with the construction of a combined church and school on Wylie Street in Pittsburgh's Hill District. Population growth necessitated a larger church, and the cornerstone for a new building was laid in 1865 on a site on Enoch Street. This 1953 image of the interior of the third St. Brigid was taken just five years prior to the church's merger with Holy Trinity. St. Brigid was razed in 1961, and the Frederick Ozanam Cultural Center was built on the site. (Courtesy Diocesan Archives.)

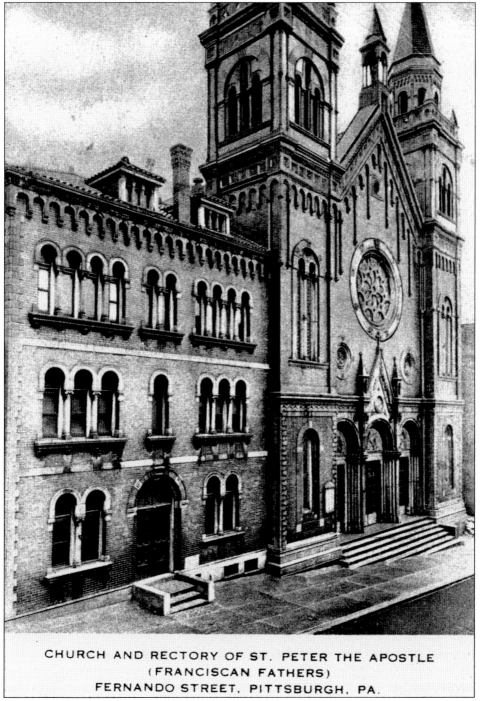

CHURCH AND RECTORY OF ST. PETER THE APOSTLE
(FRANCISCAN FATHERS)
FERNANDO STREET, PITTSBURGH, PA.

St. Peter the Apostle was established as an Italian parish in 1892 and was located on Webster Avenue in the Hill District. On November 10, 1918, a new parish on Fernando Street was dedicated. The parish was suppressed in 1960, and the land was purchased by the Urban Redevelopment Authority under eminent domain. The church and rectory were razed to make room for Chatham Center. (Courtesy Diocesan Archives.)

St. Joseph was founded in 1867 to accommodate the rapidly increasing German population in Manchester (now part of Pittsburgh's North Side). Population growth necessitated a larger church. On May 9, 1897, the cornerstone was laid for a new church located on the corner Liverpool and Fulton Streets. The church, as seen in this 1987 image, prospered for more than half a century. (Courtesy Diocesan Archives.)

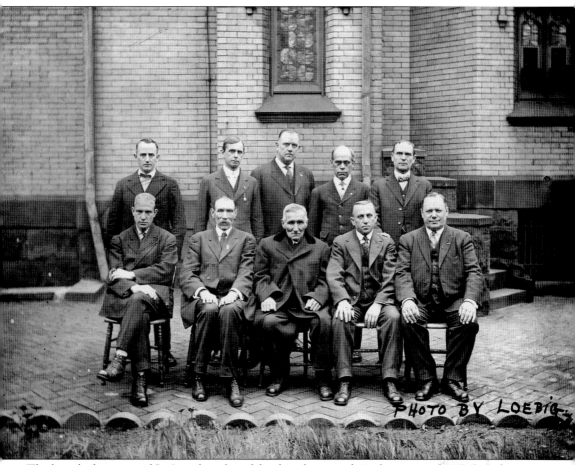

The board of trustees of St. Joseph gathered for this photograph in the spring of 1917. Seen here are, from left to right, (first row) Frank Hartman, Leopold Leibold (secretary), John Schwab, Martin Schmitt, and Egil Heil; (second row) Frank Kunkel, Peter P. Jacobs, William Berger, George W. Baur, and Louis Happ. Trustee Joseph P. Staud had passed away in 1916. (Courtesy Diocesan Archives.)

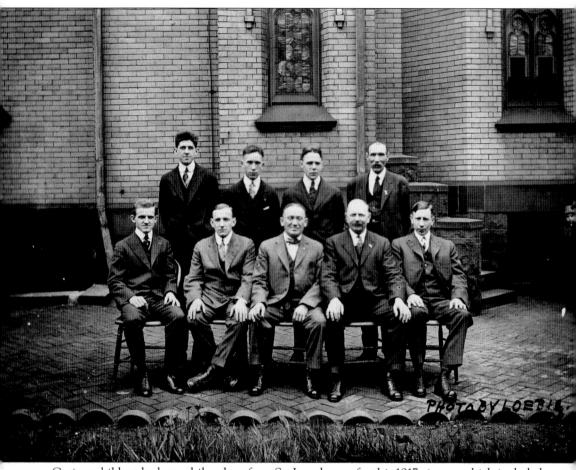

Curious children look on while ushers from St. Joseph pose for this 1917 picture, which included, from left to right, (first row) Gustave Wandrisco, Albert Snyder, Charles Faulk, Daniel Biriz, and Joseph Schwab; (second row) Henry Wandrisco, Vincent Schmitt, Charles Leibold, and chief usher Leopold Leibold. (Courtesy Diocesan Archives.)

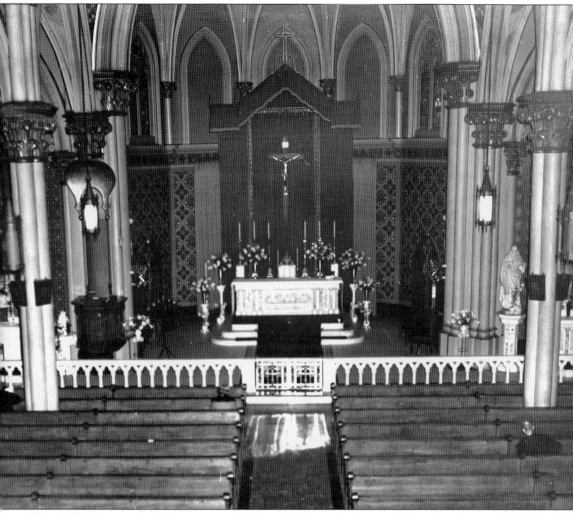

This 1958 photograph of the interior of St. Joseph shows the beauty of this church, most likely mirroring that of the old churches of Germany. As the population in the area declined, it was no longer feasible to keep the parish open. St. Joseph was closed on July 1, 1987. (Courtesy Diocesan Archives.)

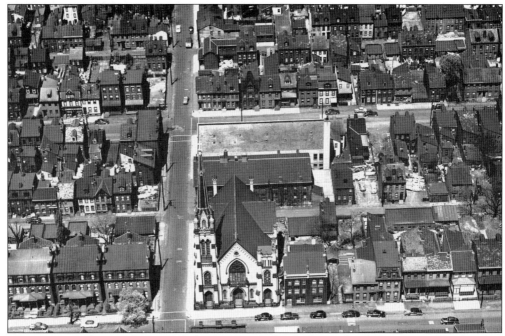

This 1958 aerial view of St. Joseph (right center) clearly shows the declining neighborhood of that decade. Parishioners were leaving the city for the suburbs. With few parishioners to serve, it was no longer realistic to keep the parish open. Maintenance and utility costs could not be supported. St. Joseph was closed on July 1, 1987. (Courtesy Diocesan Archives.)

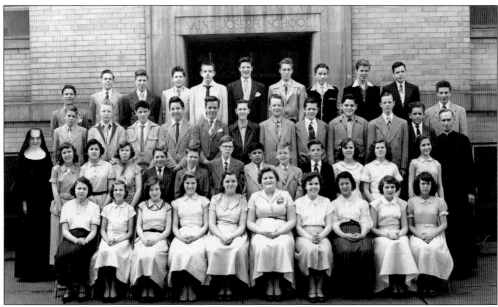

Immigrant German Catholics brought with them a tradition of and belief in the importance of a Catholic education for their children. Parishioners sacrificed to provide a proper education in the faith along with an education in reading, writing, and arithmetic. This c. 1950s image shows St. Joseph's eighth-grade class on graduation day. (Courtesy Diocesan Archives.)

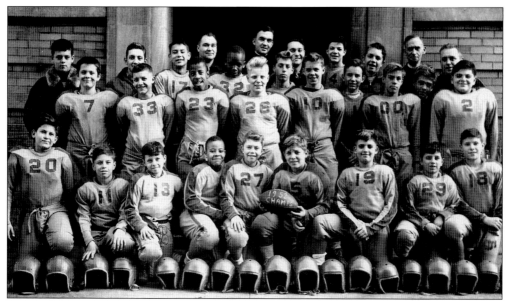

St. Joseph in Manchester also spawned a very proud sports tradition. Seen here is the 1952 championship football team, along with their coaches, teachers, and parish priests. (Courtesy Diocesan Archives.)

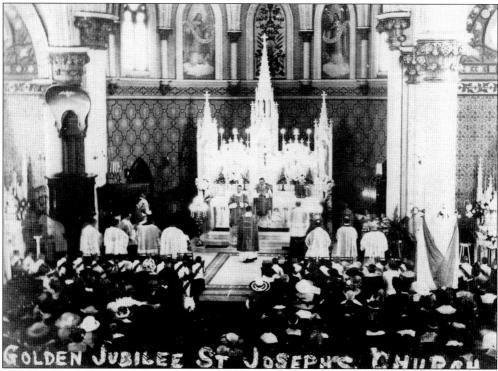

GOLDEN JUBILEE ST JOSEPHS CHURCH

Dressed in their finery with women wearing hats as was the custom at the time, faithful parishioners gather for St. Joseph Parish's Golden Jubilee Mass on June 17, 1917. Even though it was wartime, it was indeed appropriate to celebrate this joyous occasion. With the large Catholic population in Manchester, every pew was full. (Courtesy Diocesan Archives.)

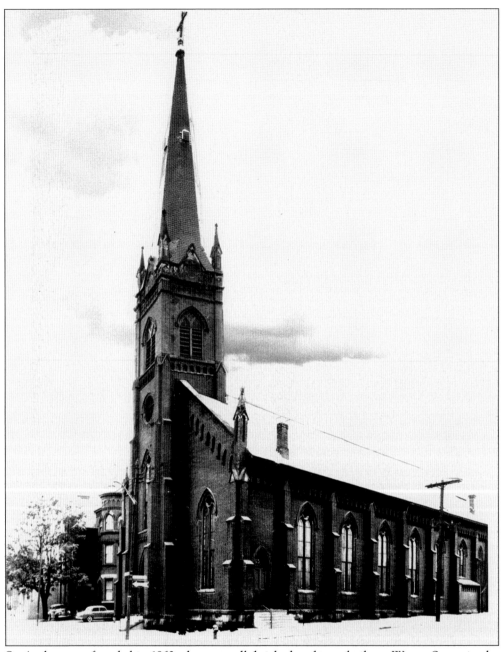

St. Andrew was founded in 1863 when a small, brick church was built on Wayne Street in the Manchester section of Pittsburgh's North Side. This *c.* 1955 image shows the second church that was built in 1872 on Beaver Avenue to accommodate the rapid population growth in the area. (Courtesy Diocesan Archives.)

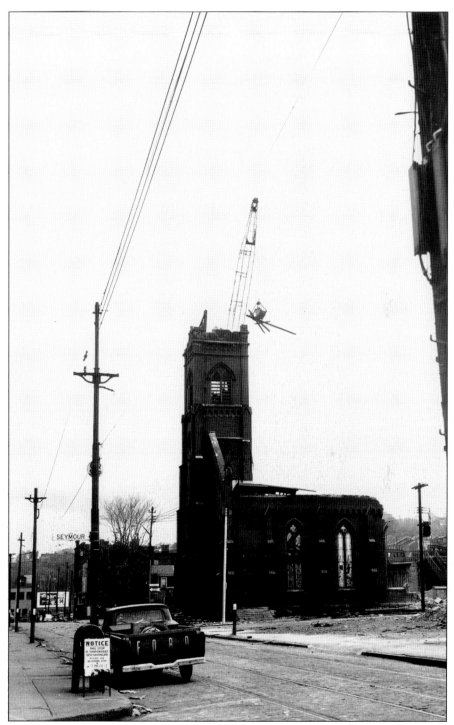

After having served the community for 90 years, including surviving a fire on March 1, 1952, St. Andrew was officially suppressed and the property sold to the Urban Redevelopment Authority to make room for an industrial park. This image shows the beginning of the demolition with the removal of the spire. (Courtesy Diocesan Archives.)

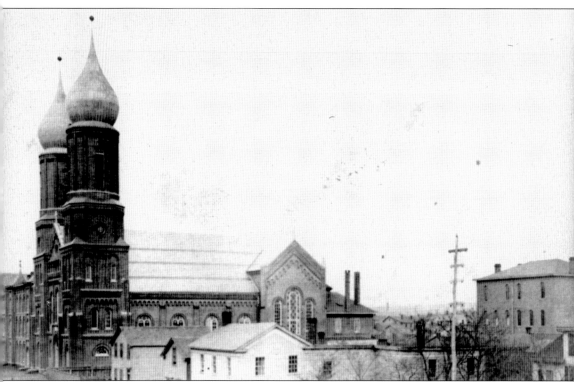

St. Mary in Allegheny City (now Pittsburgh's North Side) was founded in 1848 as a German ethnic parish. The original building on Pressley Street was a frame structure and was intended to be temporary. A new, more permanent church, seen in this undated image, was dedicated in 1853. As the population declined after World War II, it was no longer possible to support the parish. The church was suppressed in 1981, and the building was sold. (Courtesy Diocesan Archives.)

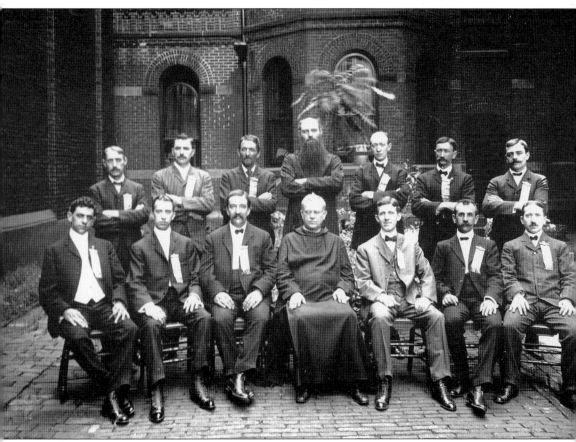

In 1903, the board of trustees of St. Mary in Allegheny City sit for a group photograph. The board of trustees members and priests gathered between the church and the priory for the occasion. (Courtesy Diocesan Archives.)

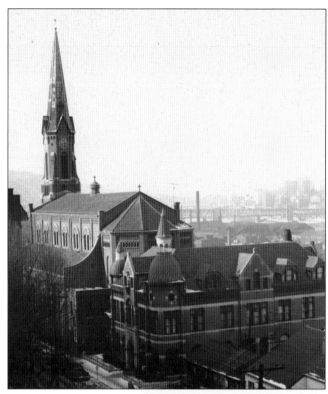

St. Michael was founded as a German ethnic parish in 1848 on Pittsburgh's South Side. The first church was a frame structure; however, within seven years, the congregation outgrew the church, and in 1855, the cornerstone for a new church was laid. The church was dedicated in 1861 and served St. Michael for more than a century. This undated photograph shows the church and school. (Courtesy Diocesan Archives.)

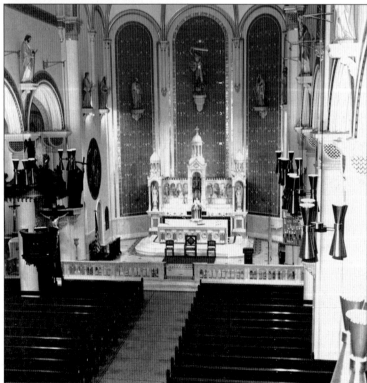

This c. 1970s photograph shows the main aisle and sanctuary of St. Michael, with its statuary, Communion rail, and old-style pulpit. (Courtesy Diocesan Archives.)

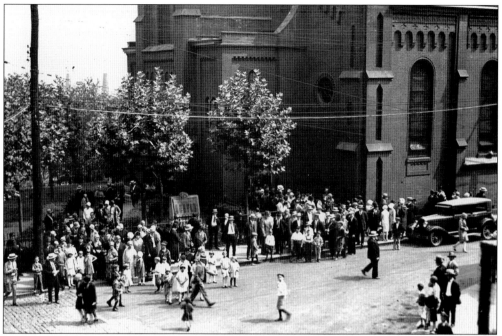

In this 1929 photograph, the congregation is seen leaving St. Michael after the annual Cholera Day Mass. Celebrated to this day, Cholera Day is the holy day set aside to honor St. Roch. Tradition holds that after 75 parishioners died in the cholera epidemic of 1849, parishioners made a solemn vow to St. Roch that if no further deaths occurred they would set aside a holy day in his name. The parish had no further deaths, and when another cholera epidemic struck Pittsburgh in 1854, no parishioners died. (Courtesy Diocesan Archives.)

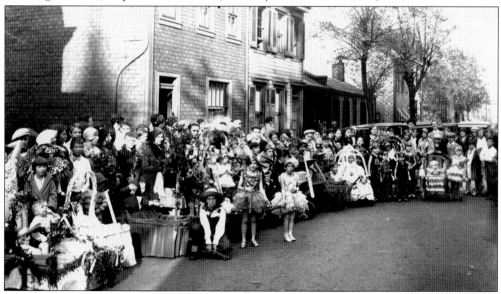

This 1929 photograph captures the baby parade, held annually as part of the Cholera Day celebration in honor of St. Roch. Grateful for his protection from the epidemics that were prevalent at the time, parents dressed their infants, toddlers, and young children in their finest to participate in this pageant in honor of the saint. (Courtesy Diocesan Archives.)

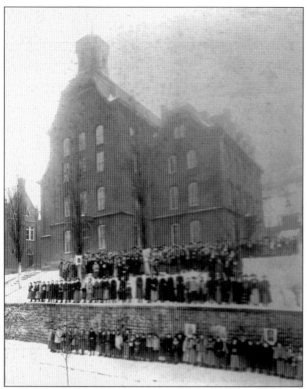

This 1889 image shows St. Michael school for girls, with students waiting in the cold for this photograph to be taken. The school was completely destroyed by fire 10 years later. While this was a devastating loss to the congregation, parishioners did not spend time mourning, but began their plans to rebuild. (Courtesy Diocesan Archives.)

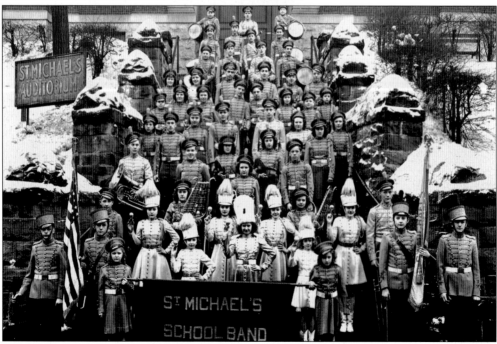

The St. Michael School Marching Band poses on the steps of the auditorium for this photograph taken in 1945. The band participated at school functions and in community events and parades. (Courtesy Diocesan Archives.)

St. Michael in the South Side was known for its theatrical performances. Known as the St. Michael Players, the drama society first stepped onto the stage in 1913, in *Veronica's Veil*, a Passion play written in 1910 in Pittsburgh. Here is the cast of *The Nut Farm*, performed in 1929. They are, from left to right, (first row) Marie Yochum, Mrs. L. McCloskey, Dorothy Goldstrom, George Helldorfer, and Margaret Mitterbach; (second row) Sylvester Schaefer, Mr. L. McCloskey, Ray Bottner, William Fuchs, and Joseph Fritz. (Courtesy Diocesan Archives.)

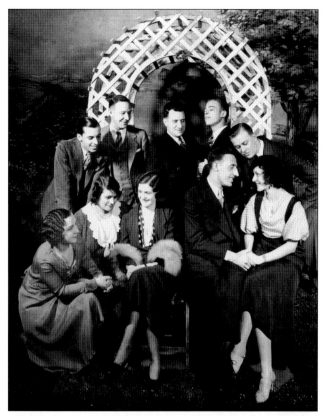

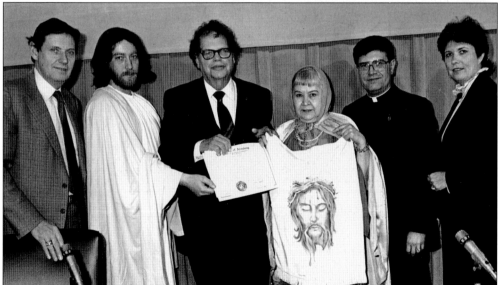

In the 1980s, Allegheny County commissioners presented a citation to honor the St. Michael Players for their long tradition of performing "Veronica's Veil" every Lenten season since 1913. Seen here are, from left to right, commissioner Peter Flaherty; a cast member portraying Christ; commissioner Thomas Flaherty; a cast member; Fr. Donald Breier, pastor of St. Michael Parish; and commissioner Barbara Hafer. (Courtesy Diocesan Archives.)

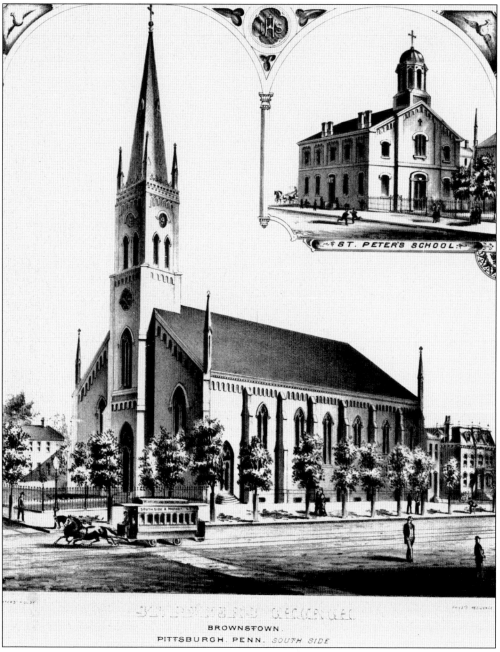

ST. PETER'S SCHOOL

BROWNSTOWN.
PITTSBURGH, PENN. SOUTH SIDE

Another German ethnic parish was St. Peter on Pittsburgh's South Side, or Brownstown. In the upper right-hand corner is the first church, dedicated in 1872. The first floor was used as a school; the second floor as the church. The lower c. 1880 photograph is of the second church that was dedicated in 1874. It served the congregation until it was completely destroyed by fire in 1952. A new church was built and dedicated in 1954. Loss of population in later decades forced the closing of the parish. (Courtesy Diocesan Archives.)

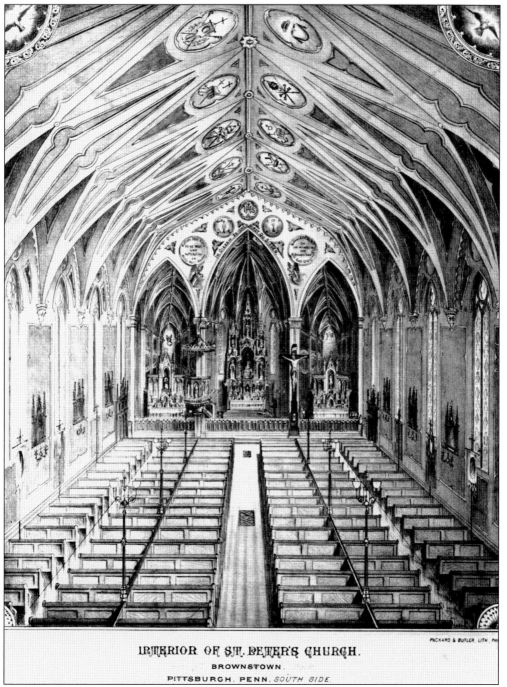

INTERIOR OF ST. PETER'S CHURCH.

BROWNSTOWN.

PITTSBURGH. PENN. *SOUTH SIDE.*

PACKARD & BUTLER. LITH. PHI

This 1873 postcard shows the interior of the first St. Peter Church with its main altar, two side altars, and old-style pulpit. In 1992, all of the South Side parishes were merged to form the newly created Prince of Peace Parish. St. Peter remains open as a worship site for Prince of Peace Parish. (Courtesy Diocesan Archives.)

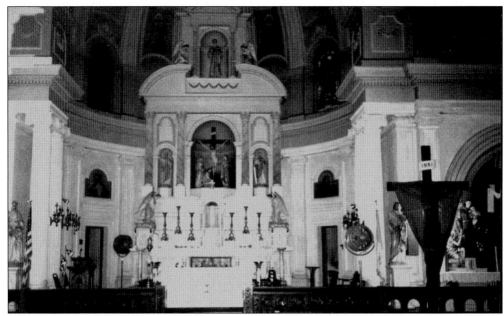

St. Casimir on Pittsburgh's South Side was the first Lithuanian church in the diocese, founded in 1893 as a result of the influx of Lithuanian immigrants who came to work in the mills. Initially congregants worshipped in the basement of St. Paul Cathedral, then in an old Protestant church on Carson Street. Within a few years, the parish bought a lot on Sarah Street for the building of a new church. This *c.* 1990 image shows the glorious main altar. (Courtesy Diocesan Archives.)

St. Casimir Fraternal Society officers sat for this *c.* 1920 image. As was typical of most immigrant groups in southwestern Pennsylvania, the Lithuanians formed their own ethnic fraternal organizations. Many of these societies exist to this day. Members cherish the traditions of their immigrant ancestors and pass them down to the next generation. (Courtesy Diocesan Archives.)

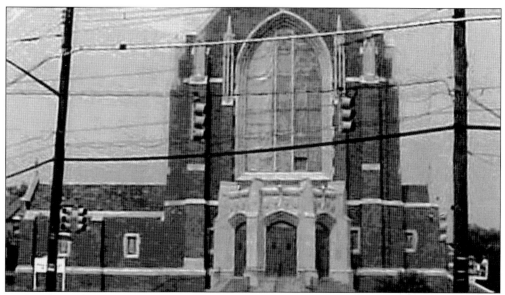

With industrial expansion came a rise in the immigrant population on the North Side. In 1894, local Catholics petitioned the bishop for a parish of their own; the petition was granted and the first Mass in St. Francis Xavier was celebrated in a rented commercial building. Construction soon began on a school, with the first floor to be used as a church. This temporary church served the parish for 30 years. A permanent church was built in 1926–1927. This church, as seen in this 1933 picture, served as an independent parish for almost 70 years. It is now a worship site for Risen Lord Parish. (Courtesy Diocesan Archives.)

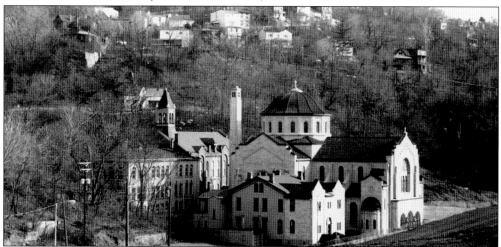

Originally a mission church of St. Mary, North Side, St. Boniface became an independent parish with the appointment of Rev. Bede Hipelius as pastor in 1888. At the same time, the combination church and school building was expanded and dedicated in 1889. Jobs were plentiful in the nearby mills and factories, and it soon became apparent that a larger church was needed. A new, more grand church was built and dedicated in 1926. In 1971, parishioners launched a public outcry when the Pennsylvania Department of Transportation used eminent domain to purchase the property to make room for a new highway. After a 10-year battle, the parishioners prevailed, and the church was sold back to the diocese. The path of the highway was diverted. (Courtesy Diocesan Archives.)

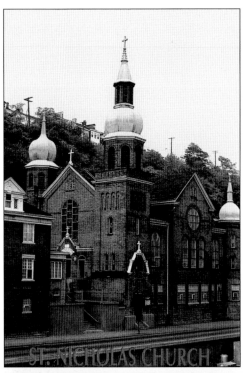

Founded in 1894, St. Nicholas on the North Side was the first Croatian church in the United States. In 1894, the local community wrote to Croatia to ask that a priest be sent to Pittsburgh. In August 1894, the parish's first Mass was celebrated in the basement of St. Paul Cathedral. By fall of that year, a building was purchased on East Ohio Street and converted to a church. It soon proved inadequate to accommodate the burgeoning Croatian population. This image shows the church that was built and dedicated in 1895. (Courtesy Diocesan Archives.)

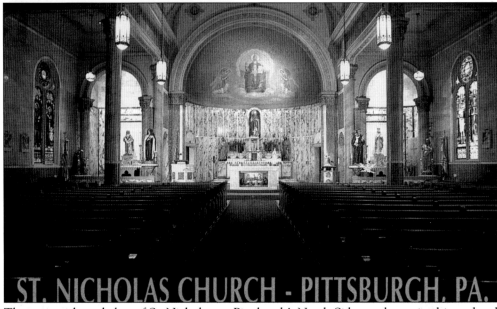

The main aisle and altar of St. Nicholas on Pittsburgh's North Side are shown in this undated postcard image. Once again, the Pennsylvania Department of Transportation made plans to change the highway system leading into the city and purchased the property from the diocese. The church was scheduled for demolition. The parishioners of Croatian descent made a valiant effort to raise enough funds to buy the property back, given the church's historical significance in the United States. In this case, however, the parishioners did not prevail. As of this book's publication, the building's fate is yet to be decided. (Courtesy Diocesan Archives.)

Two

THE STEEL VALLEY

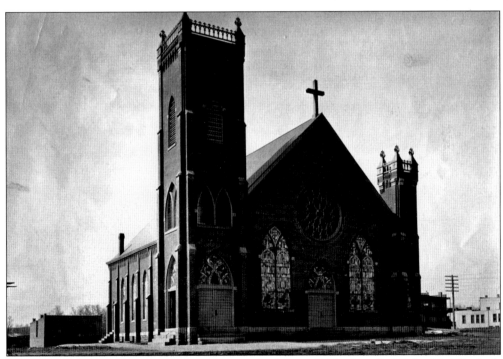

The origins of the faith community in Clairton harken to 1895, when St. Michael in Elizabeth established a mission in Clairton. At that time, Mass was celebrated in a room of the T. Campbell Glass Company. As the steel industry prevailed and jobs were plentiful, more immigrants moved into Clairton, and a church was built on Wilson Avenue. Dedicated in 1904, the first St. Clare of Assisi church, seen here, survived until 1924 when a fire completely destroyed the building. (Courtesy Diocesan Archives.)

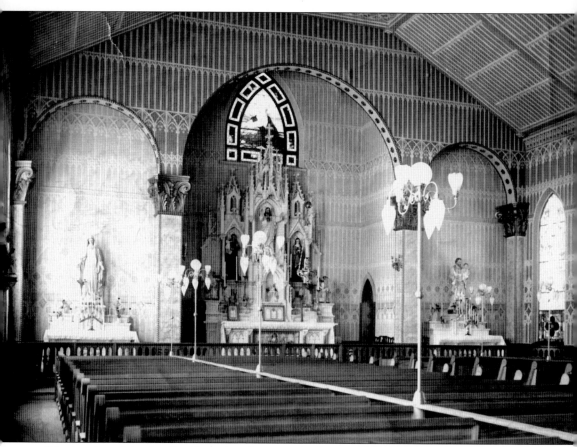

The interior of the first St. Clare church was magnificent with its main altar and two adjacent side altars. St. Clare remained a mission of St. Michael in Elizabeth until April 1907, when the first pastor was assigned. After the fire of 1924, what was to have been a temporary frame structure was built; it served the parish, however, for 30 years. The third St. Clare church was dedicated in 1954. (Courtesy Diocesan Archives.)

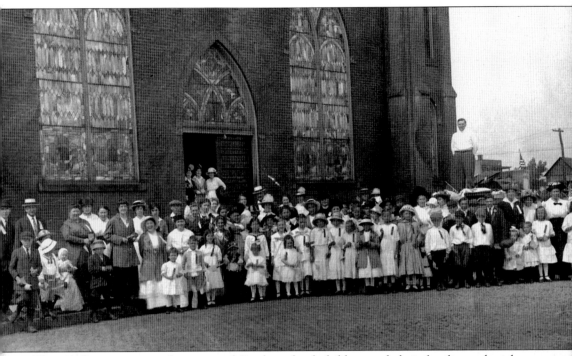

This 1915 image captured a group of Sunday school children and their families gathered at St. Clare church. They are appropriately dressed and prepared for a picnic in Olympic Park in McKeesport. (Courtesy Diocesan Archives.)

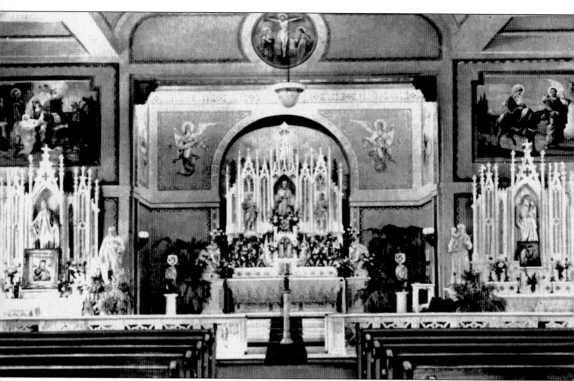

Immigrants from many nations came to the area along the Monongahela River, lured by the abundance of industrial jobs, particularly in the steel industry. In 1891, St. Francis of Assisi was established as a German parish. Very little is documented about the founding of the parish. Until the church building was completed and dedicated in 1891, Mass was celebrated in a rented hall. A resident pastor was appointed in 1892. This undated image shows the interior of the second St. Francis of Assisi church at 815 McClure Street in Munhall. (Courtesy Diocesan Archives.)

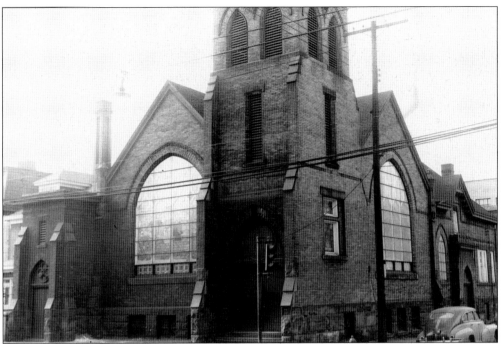

With the burgeoning of the steel industry in Braddock at the beginning of the 20th century, more European immigrants arrived in the area for the abundant jobs. By 1916, enough Lithuanians had arrived in the area to support their own parish. This *c.* 1950s image shows the church they constructed on Talbot Street in 1916 and dedicated to St. Isidore. (Courtesy Diocesan Archives.)

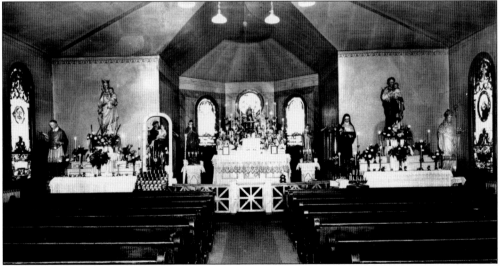

The interior of St. Isidore, around 1946, contained the main altar and traditional side altars. With the devastating closing of the Edgar Thompson Works of the United States Steel Company in 1982, many parishioners moved away in search of jobs. This decline in population led to the 1985 merger of all of the Braddock-area churches into the new parish of Good Shepherd. After the merger, St. Isidore was sold and is now the First Church of God in Christ. (Courtesy Diocesan Archives.)

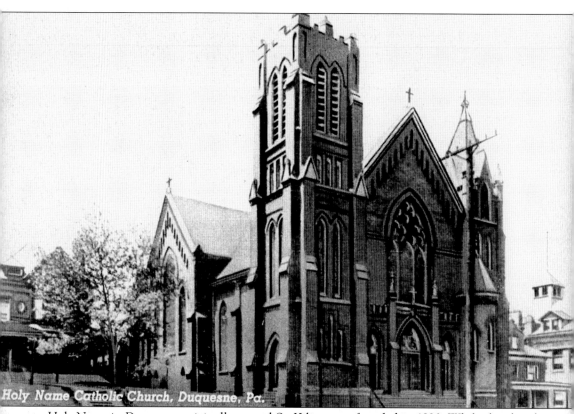

Holy Name Catholic Church, Duquesne, Pa.

Holy Name in Duquesne, originally named St. Kilian, was founded in 1890. While the church was being built, Mass was celebrated in a commercial building. By 1891, a frame structure was completed and served the faith community until 1899, when it was destroyed by fire. The congregation again found a commercial building in which to celebrate Mass until the new building was complete and dedicated in 1901, when it was renamed Holy Name. On March 29, 1928, lightning struck the steeple. It was never replaced. This 1934 postcard image shows the church, sans one steeple. (Courtesy Diocesan Archives.)

In November 1916, many clergy gathered with Fr. David Shanahan to concelebrate the Silver Jubilee of Holy Name Parish in Duquesne. By the end of the century, the population in Duquesne would have declined to the degree that a merger of parishes would be inevitable. In 1994, Holy Name Parish merged with St. Hedwig to form the new Christ the Light of the World parish. Holy Name remains open and serves the new parish. (Courtesy Diocesan Archives.)

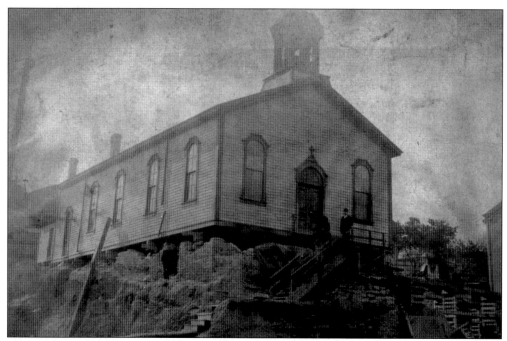

With the growth of the steel industry in Homestead and the resultant growth of the population in search of employment in the mills, St. Mary Magdalene was founded in 1881, the first Catholic church in Homestead. At first, Masses were said in a local grocery store. As with other churches in the rapidly growing area, the building soon could not accommodate the growing number of congregants. This 1881 image is of the first St. Mary Magdalene. (Courtesy Diocesan Archives.)

Fr. John J. Bullion was the first pastor of St. Mary Magdalene in Homestead. He served from 1881 until 1916 and saw the parish through the building of a new frame church in 1888 to accommodate the growing number of parishioners. He also saw the congregation through the fire that completely destroyed the church, school, and convent in 1890. (Courtesy Diocesan Archives.)

The cornerstone for a new St. Mary Magdalene was laid in 1895, and the completed church was dedicated in December 1896. This new church on Amity Street was large, with 150-foot-high steeples and seating for 1,200. It was also totally destroyed by fire. A new church rose from the ashes and was dedicated in 1936. Again in 1977, fire struck and caused significant damage, although the building itself was saved and restored. This c. 1970 image is a view of the interior just prior to the renovations made by Fr John Habey. (Courtesy Diocesan Archives.)

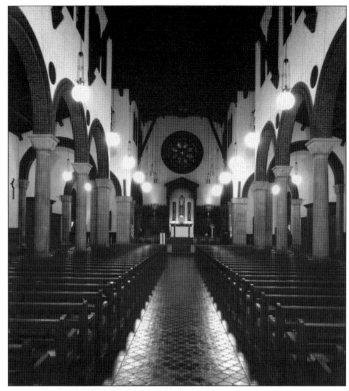

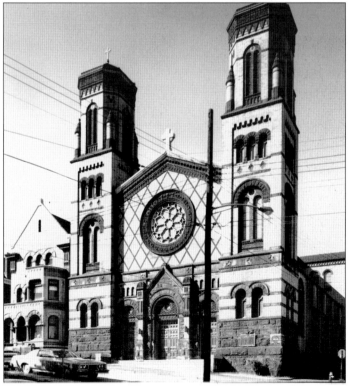

This 1979 view of St. Mary Magdalene is testament to the tenacity and spirituality of the Homestead community. In 1992, the church was merged with other Homestead and Munhall parishes and was to have been closed. The community raised enough money to convince the diocese to keep open the first Catholic church in Homestead. Today it serves as a worship site for St. Maximilian Kolbe. (Courtesy Diocesan Archives.)

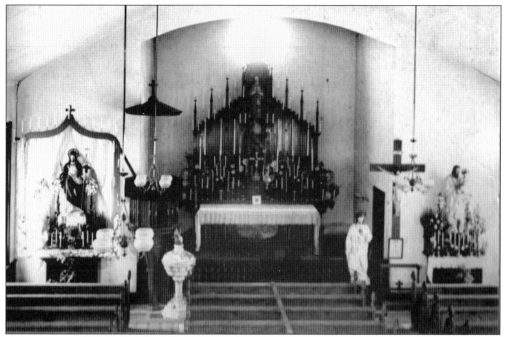

St. Mary (German) in McKeesport was founded in 1887, the result of local German Catholics petitioning the bishop for a school where the German language would be spoken. A private hall, Ryan's Hall, was used for the celebration of Mass until the combined church and school were completed and dedicated in 1888. The first floor served as the school, the upper floor served as the church. This undated image shows the interior of the church on the second floor. (Courtesy Diocesan Archives.)

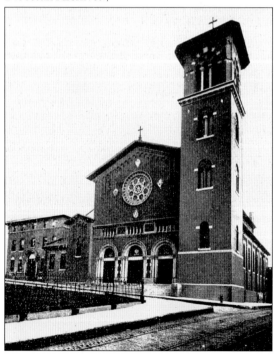

Steady population growth led to overcrowding, and work began on a new church to be built in the early Christian Basilica model; the only church of its type in the United States, it was dedicated in 1908. This image shows a front view of St. Mary German Catholic Church as it stood in 1933. The church was renovated at least three times until it was suppressed and merged with other McKeesport parishes to form the new Parish of St. Martin de Porres. In 1993, the murals were sold, and the building was razed in 1997. (Courtesy Diocesan Archives.)

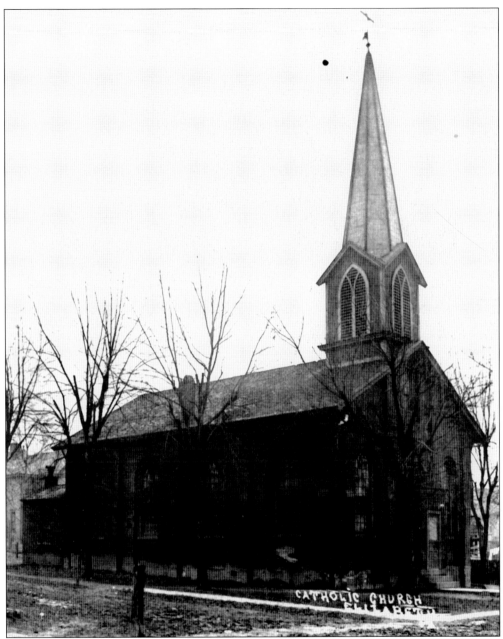

Founded in 1851 in Elizabeth, St. Michael was the consequence of an influx of immigrants in search of jobs in the coal mines. This undated image shows an exterior view of the original church that was dedicated in 1851 and served as a mission church. Not until 1855 was a resident pastor assigned. By 1908, the existing church could no longer accommodate the growing number of parishioners and an addition was constructed. (Courtesy Diocesan Archives.)

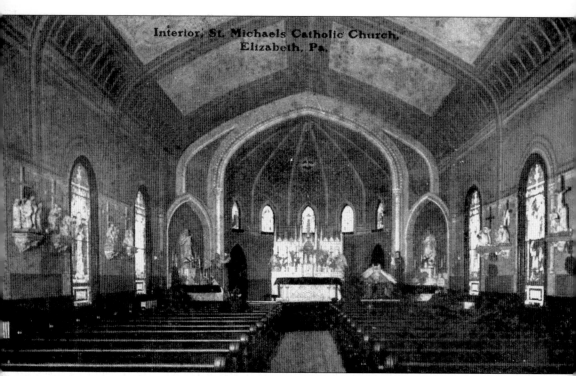
Interior, St. Michaels Catholic Church,
Elizabeth, Pa.

This undated postcard shows the interior of the original St. Michael in Elizabeth. The church served the parish until the mid-1980s. Extensive repairs to the building were needed, and it was decided to move the church from Elizabeth Borough to Elizabeth Township, where it would be more centrally located within the parish. The congregation was divided, with some supporting the move and others against it. Those disagreeing with the diocese's decision filed a lawsuit and appealed the decision to the Vatican. This delayed the move and construction of a new church, which did not occur until 1987. (Courtesy Diocesan Archives.)

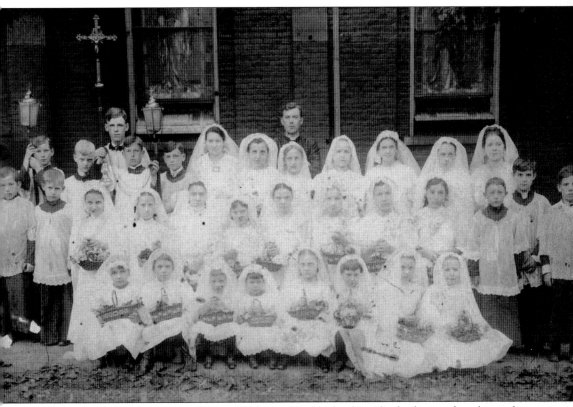

In this early, undated photograph, the children of St. Michael in Elizabeth pose for a keepsake portrait of May Procession honoring the Blessed Virgin Mary. (Courtesy Diocesan Archives.)

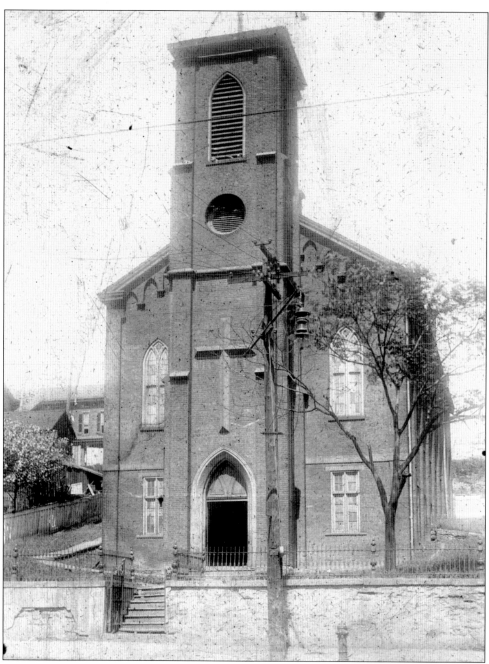

St. Thomas was the first Catholic church to be established in Braddock. In 1854, St. Thomas began as a mission church in a chapel not physically located in Braddock, but across the Monongahela River from Braddock on Tara Hill. This chapel did not have a resident pastor, nor was it named or dedicated. Crossing the river and climbing the hill, particularly in bad weather, to attend Mass soon became too difficult a journey, particularly in inclement weather. Therefore a new, still unnamed, church was built in Braddock, and the first Mass was celebrated in October 1861. The church was dedicated to St. Thomas a year later, and the last Mass in the old chapel on Tara Hill was held on March 17, 1863. (Courtesy Diocesan Archives.)

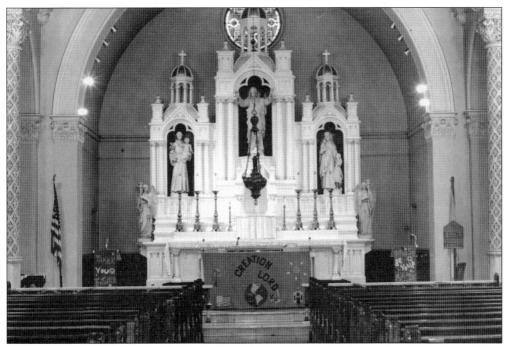

The church was dedicated to St. Thomas in 1862 and the last Mass in the old chapel on Tara Hill was held on March 17, 1863. This 1973 image shows the main altar of the new St. Thomas church. (Courtesy Diocesan Archives.)

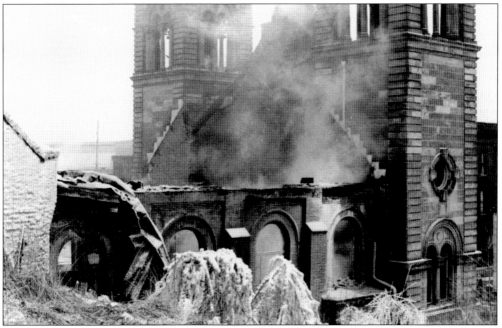

The new St. Thomas in Braddock served the faith community until 1983 when it was completely destroyed by fire. By the 1980s, the steel industry was in a downward spiral, and what jobs remained were in short supply. The population dropped dramatically as families left the area in search of well paying jobs. (Courtesy Diocesan Archives.)

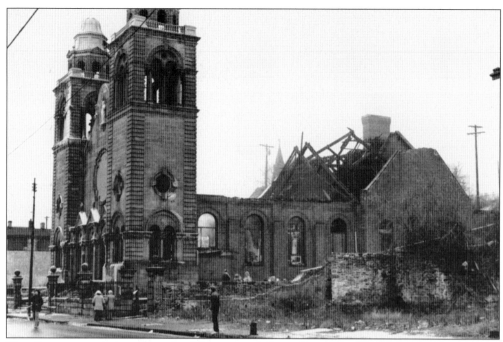

The diocese commissioned a study of the status of all parishes in Braddock. The consensus of the commission was not to rebuild St. Thomas but to consolidate all of the parishes in Braddock into one and dedicate it to the Good Shepherd. In February 1984, St. Thomas was razed. (Courtesy Diocesan Archives.)

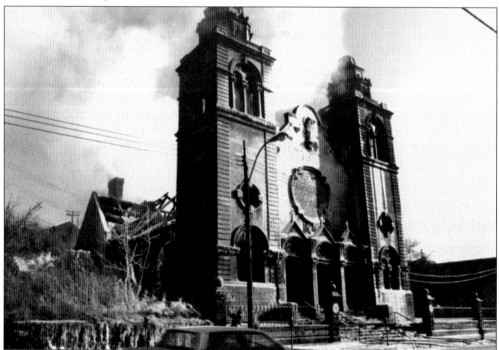

This front exterior view of St. Thomas in Braddock is a melancholy remembrance of the greatness that was once St. Thomas and the borough of Braddock. (Courtesy Diocesan Archives.)

Three

PITTSBURGH AND ITS ENVIRONS

St. Walburga in East Liberty was founded as a German ethnic parish in 1903. The original church was damaged by fire in 1920 and was repaired and enlarged in that same year. In this c. 1920 image, the church can be seen in the upper left, next to the rectory. (Courtesy Diocesan Archives.)

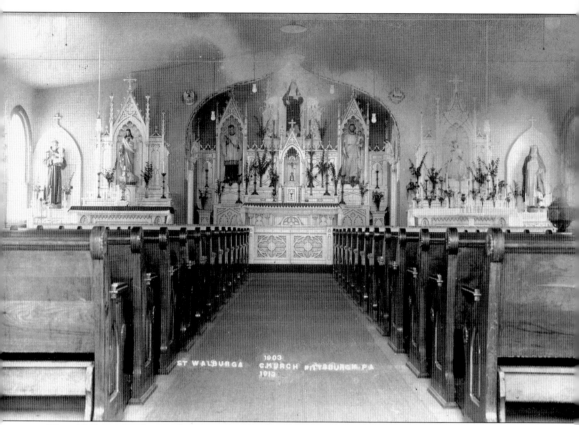

This 1913 image shows the interior of St. Walburga. Not much is know about the history of this parish. It was named for St. Walburga, born into the aristocracy in England and entrusted at an early age to the care of the Benedictine nuns. When her relative St. Boniface asked for the assistance of Angle-Saxon monasteries for the evangelization of Germany, St. Walburga answered the missionary call. She was known for her humility, charity, and gentleness, as well as her ability to heal the sick through prayer. Many years after her death, her bones were taken from Heidenheim to the town of Eichstatt, where they were entrusted to a community of Benedictine nuns founded for the purpose of maintaining her shrine. (Courtesy Diocesan Archives.)

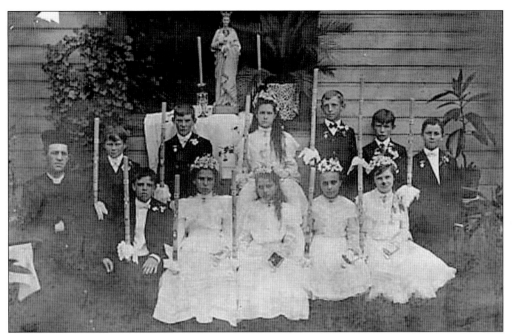

Although the parishioners of St. Walburga were not wealthy, it was important to dress their children appropriately for their First Holy Communion, as is seen this 1915 photograph. (Courtesy Diocesan Archives.)

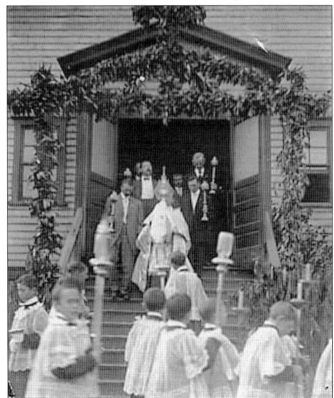

This undated photograph captured the Veneration of the Blessed Sacrament procession at St. Walburga. The early immigrants to southwestern Pennsylvania carried their faith traditions with them and passed them to the next generation. (Courtesy Diocesan Archives.)

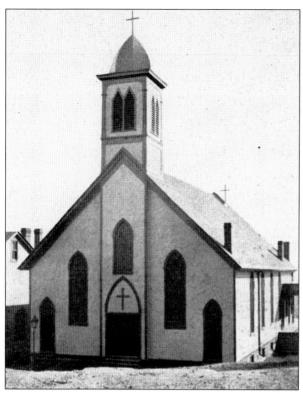

In 1886, the German-speaking congregation of St. Ann in Millvale broke away to form their own parish in that borough. St. Anthony was founded in 1886, and work immediately began on a frame structure that was completed in 1887, as seen in this undated image. The building served parishioners for more than 20 years, first as a church and later as a parish lyceum. It was destroyed by fire in 1923. (Courtesy author's private collection.)

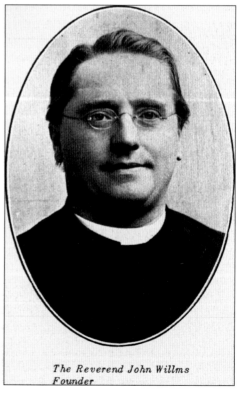

The Reverend John Willms
Founder

The Reverend John Willms, C.S. Sp. was the founder and first pastor of St. Anthony in Millvale, serving from 1886 until 1892. One of his first actions was to establish the Christian Mothers Society. Eventually Father Willms was named director of the Holy Childhood Association of the United States. It was written of him that "Father Willms . . . was a priest of robust and stocky physique. He was gifted with oratorical powers and eminently fitted for field work." (Courtesy author's private collection.)

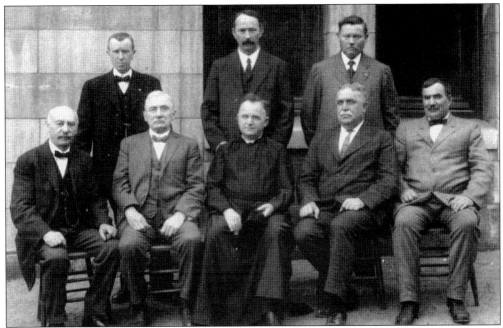

The congregation of St. Anthony soon outgrew the small church. Work began on a new structure in 1913. The building committee members seen in this 1914 image were, from left to right, (first row) Louis Spreng, Peter Kress, Fr. Louis Spannagel, Peter Ritter, and Ambrose Sirlin; (second row) Ignatz Guenter, Joseph Balker, and Frank Pschirer Sr. (Courtesy author's private collection.)

Appreciating the importance of a Catholic education for their children, the congregants of St. Anthony built a small, brick German schoolhouse in 1876. For the first six years of its existence, the faculty consisted of four laywomen from Millvale. The Fransiscan nuns were petitioned to serve as faculty and administrators in 1884 and had to travel daily from Sharpsburg to Millvale for classes. (Courtesy author's private collection.)

In 1892, Father Zielenbach, C.S. Sp., came to St. Anthony Parish and personally visited the then-339 families of the parish to impress upon them the need for a new school since the old structure could no longer accommodate the number of children attending classes. Parishioners overwhelmingly responded to his call, and on December 1, 1893, this new school was dedicated. The building served the needs of this rapidly growing parish for almost 70 years, a testimony to the clear vision of the early founders of this parish. (Courtesy author's private collection.)

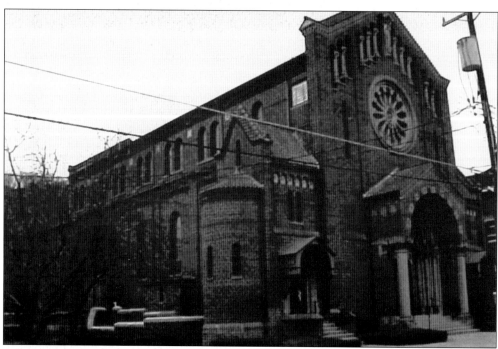

Around 1900, the Catholic population of Etna was served by All Saints on Wilson Street. The first church was a small frame building dedicated in 1902. As occurred with many other parishes, the church soon became inadequate to serve the burgeoning population and was replaced in 1915 with the current church seen in this undated image. (Courtesy Diocesan Archives.)

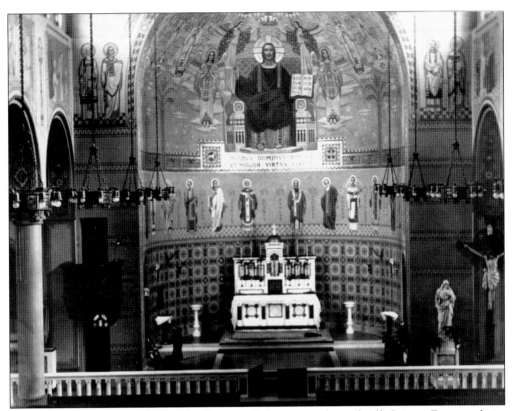

This undated image celebrates the beauty of the main altar of All Saints, Etna, with its magnificent murals of the saints. (Courtesy Diocesan Archives.)

Plans for St. Joseph in Mount Oliver were begun during the Civil War. Due to the war and the limited financial means of the Catholic population, however, groundbreaking was delayed until 1868. The cornerstone was laid, and the church was dedicated in 1870. The church was renovated in 1895 and again in 1930. (Courtesy Diocesan Archives.)

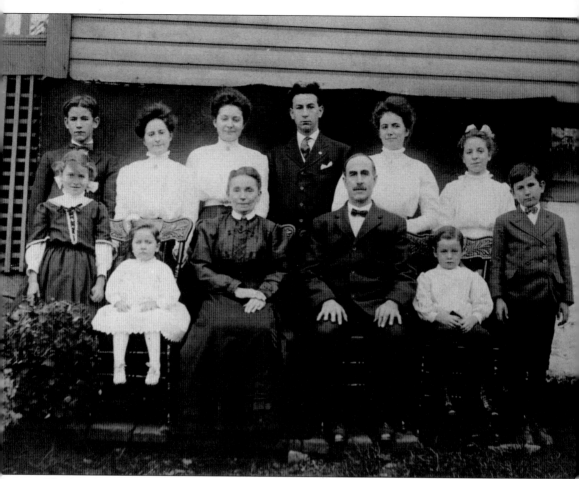

The Buechel family, parishioners of St. Joseph, gather for a family portrait in 1910. Seen here are, from left to right, (first row) Hilda, Philomena, Magdelena, Henry, Frank, and George; (second row) Edward, Catherine, Christena, Joseph, Mary, and Elizabeth. Henry was employed as a mill worker. Philomena, the youngest of 10 children, entered the convent of the Sisters of St. Francis in Millvale, professing her vows on August 13, 1933, taking the name Sister M. Harriet, O.S.F. (Courtesy Private collection of Barbara Kirsch Regalski.)

On February 15, 1951, a fire destroyed St. Joseph. In the aftermath, the congregation initiated plans for a new church and work began shortly afterward. The new edifice was dedicated in June 1953. (Courtesy Diocesan Archives.)

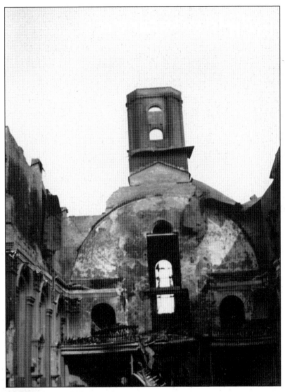

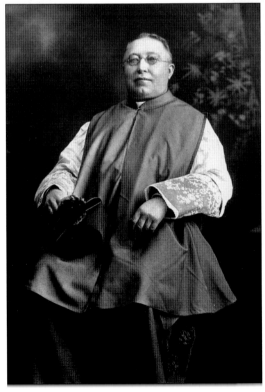

Seen here in this undated portrait, Msgr. Herman Goebel was pastor of St. Joseph from 1897 to 1925. (Courtesy Diocesan Archives.)

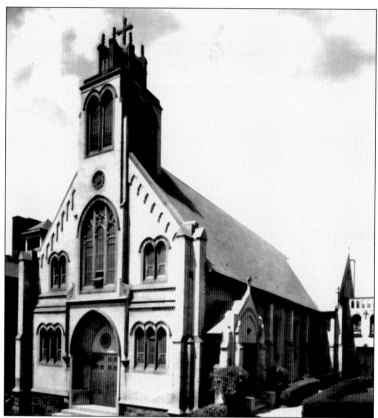

Mother of Sorrows, an Italian ethnic parish, was founded in 1906 in McKees Rocks. The church, pictured here around 1940, is the second Mother of Sorrows. The first church was destroyed by fire in 1928. (Courtesy Diocesan Archives.)

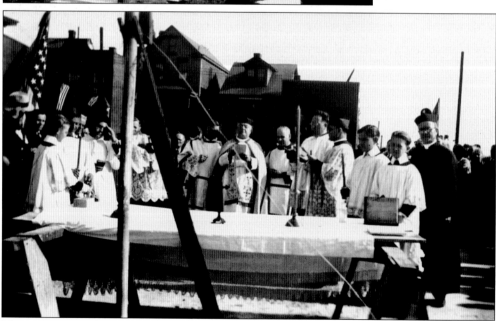

The cornerstone for the second Mother of Sorrows was laid in 1929. The Mother of Sorrows blessing occurred in 1929, and the building was completed and dedicated in 1930. (Courtesy Diocesan Archives.)

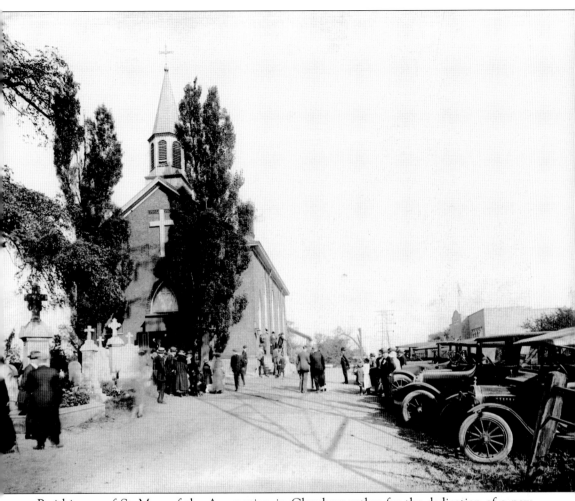

Parishioners of St. Mary of the Assumption in Glenshaw gather for the dedication of a new school building in 1924. Bishop Hugh C. Boyle officiated. St. Mary of the Assumption was founded in 1840 in Pine Creek, after a group of local Catholics took it upon themselves to build a log church that subsequently served as a mission of St. Patrick in the Strip District. (Courtesy Diocesan Archives.)

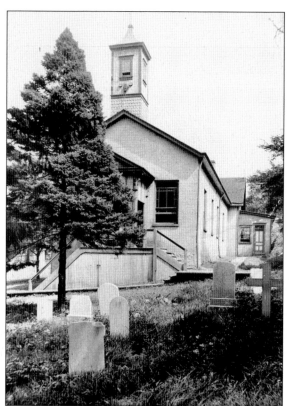

The origins of St. Philip in Crafton can be traced to 1829, when a local farmer arranged for a priest from Pittsburgh to celebrate Mass once a week in his farmhouse. Otherwise Catholics had to travel to the city to attend Mass and receive the Sacraments. In 1838, the parishioners purchased land and began work on a small, brick church. A completed St. Philip was dedicated in 1839. However, St. Philip remained a mission of other parishes until 1877, when it became an independent parish with the assignment of its first resident pastor. (Courtesy Diocesan Archives.)

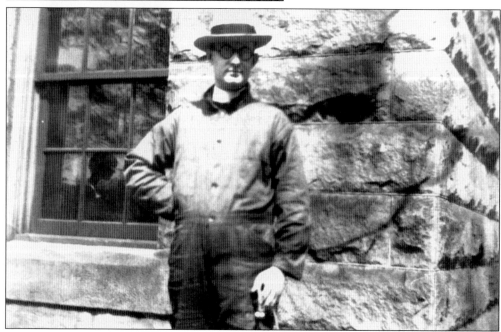

Rev. Alvin Forney was assigned to St. Philip parish in 1923 as assistant to Father Kelty. Reverend Forney has the distinction of being the parish's first assistant pastor. (Courtesy Diocesan Archives.)

St. Philip School was built in 1915 by Father Kelty. The building consisted of nine classrooms and two offices. (Courtesy Diocesan Archives.)

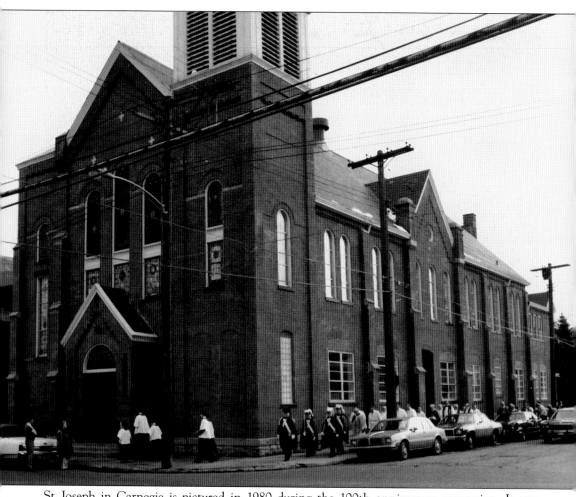

St. Joseph in Carnegie is pictured in 1980 during the 100th anniversary procession. It was founded in 1879 as a German ethnic parish. (Courtesy Diocesan Archives.)

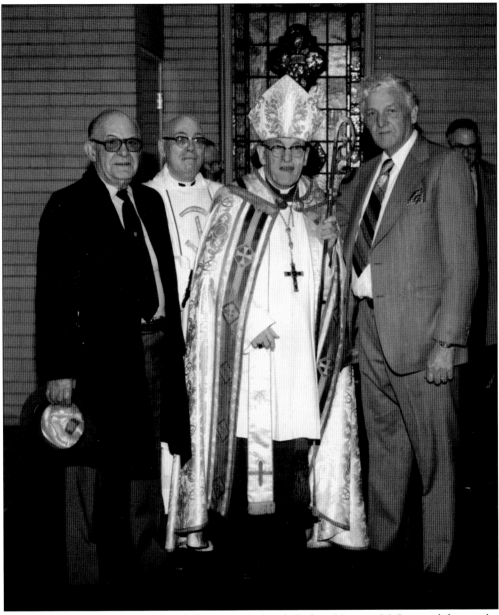

Fr. Sylvester J. Kress (second from left) is pictured with Bishop Vincent M. Leonard during the 100th anniversary celebration at St. Joseph in Carnegie. (Courtesy Diocesan Archives.)

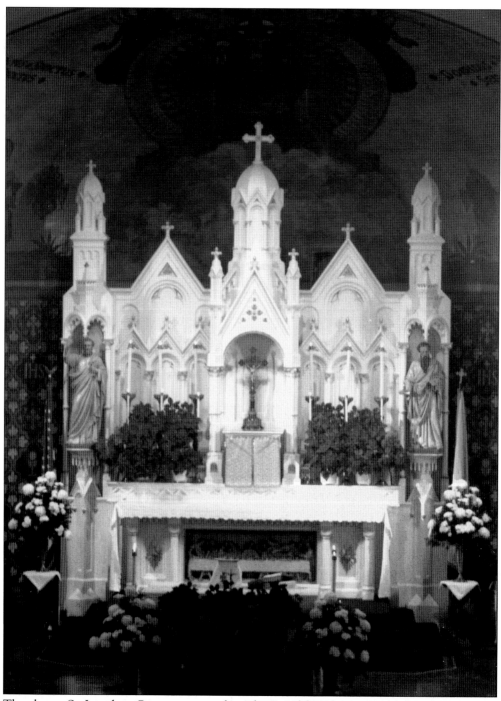

The altar at St. Joseph in Carnegie is seen here decorated for Christmas in 1979.

Little is known about the origins of St. Wendelin in Carrick. It was founded in 1873, and its small, frame church was visited by a priest, first from St. Paul Monastery and then from St. Peter, South Side. In 1876, the church was assigned its first resident pastor. By the late 19th century, the congregation had outgrown the tiny church and a new edifice was completed and dedicated in 1897. In this 1919 image, Fr. Julius Utecht (left) and Fr. Frederick J. Seibel pause after the blessing of the rectory on December 14, 1919. (Courtesy Diocesan Archives.)

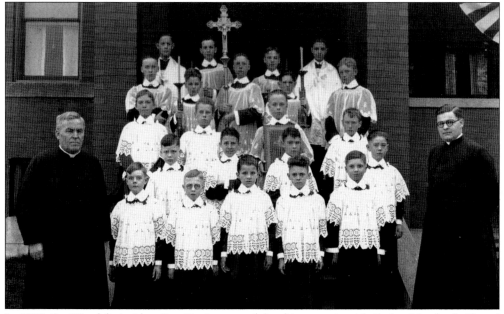

In 1923, St. Wendelin's Altar Boy Society posed for this portrait with Father Utecht (left) and Fr. Henry Hanse. As was customary in all Catholic parishes, young boys were encouraged to serve at the altar during the celebration of the Mass and at other sacraments and processions. (Courtesy Diocesan Archives.)

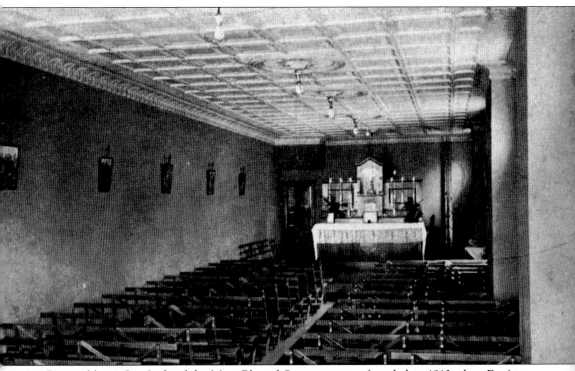

Pictured here, Our Lady of the Most Blessed Sacrament was founded in 1910 when Fr. August Black rented a storeroom on Fransktown Avenue to celebrate Mass. Fund-raising immediately began, and a church was completed and dedicated on June 1, 1914. Six years later the church opened a school, which operated until 1937. (Courtesy Diocesan Archives.)

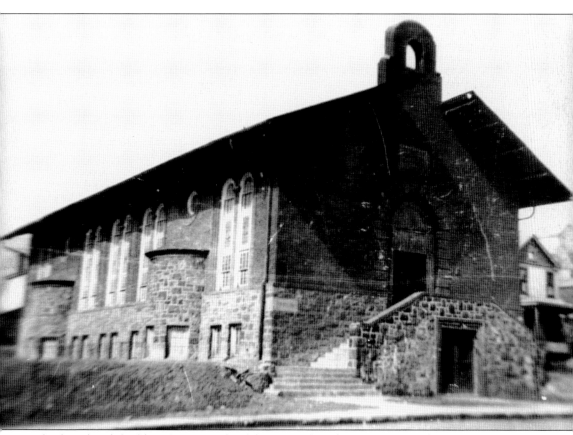

The first church building for Our Lady of the Most Blessed Sacrament was dedicated on June 1, 1944. This building was razed in 1961 upon the completion of a new church the year before. (Courtesy Diocesan Archives.)

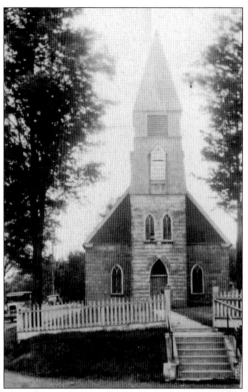

In response to the growing Irish population in the area, St. Alphonsus in Murrinsville was founded in 1841, although a resident pastor was not named until 1850. Prior to 1841, Mass was celebrated in the home of Hugh Murrin, after whom the town was named. In December 1892, fire destroyed the interior of the church; rather than raze the structure, however, parishioners decided to renovate the building, and the new church was dedicated in 1893. This undated image shows one of the earlier churches. (Courtesy Diocesan Archives.)

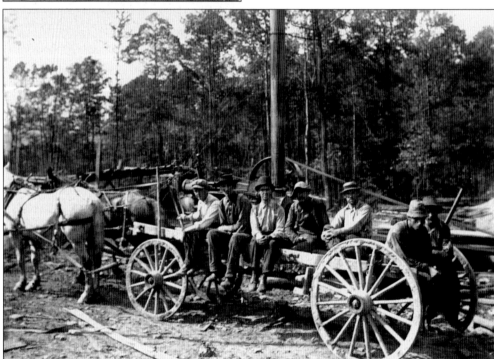

The land on which St. Alphonsus sits was originally part of the farm owned by the Charles Gormley family and was donated to the congregation. (Courtesy Diocesan Archives.)

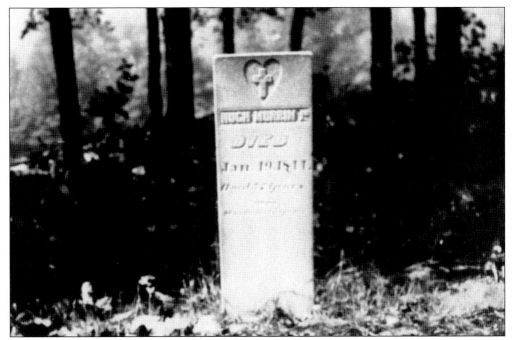

Hugh Murrin died on January 19, 1811, at the age of 91, and was interred in Sarver Cemetery. He was the original owner of the land on which St. Alphonsus was constructed. (Courtesy Diocesan Archives.)

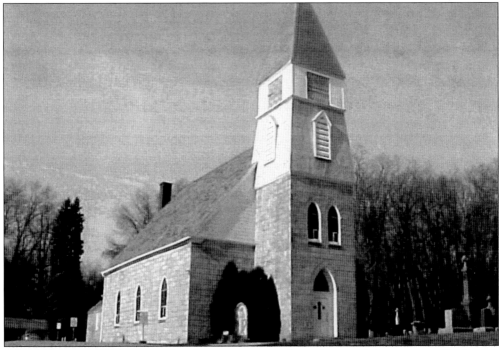

After the fire in 1892, a new church was constructed on the remaining stone walls. In this recent photograph of St. Alphonsus, the original structure is clearly identifiable. (Courtesy Diocesan Archives.)

In 1845, German immigrants to the Carbon Center area built a small log school and chapel. For the first few years, the chapel was used for organized prayer services. In 1851, priests from St. Philomena or St. Patrick in Sugar Creek occasionally visited to say Mass and perform the sacraments. This c. 1970 photograph shows the second church, St. Wendelin, which was built in 1875 to accommodate the growing population. The adjacent rectory was built in 1926. (Courtesy Diocesan Archives.)

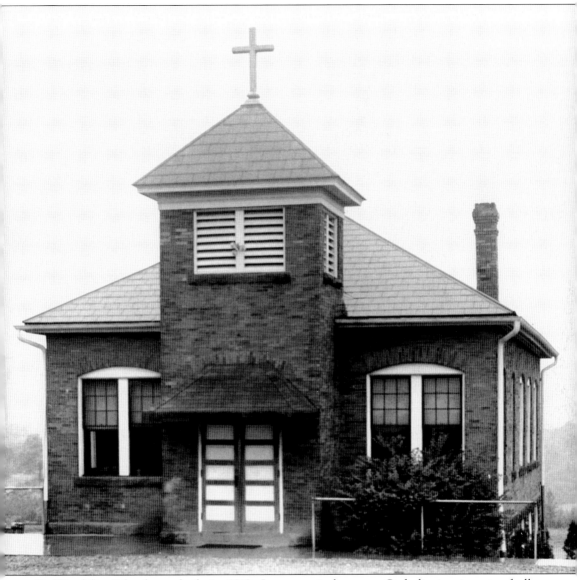

St. Wendelin School was built in 1912. It was typical among Catholic immigrants of all ethnicities to provide a Catholic education for their children, often at considerable sacrifice. (Courtesy Diocesan Archives.)

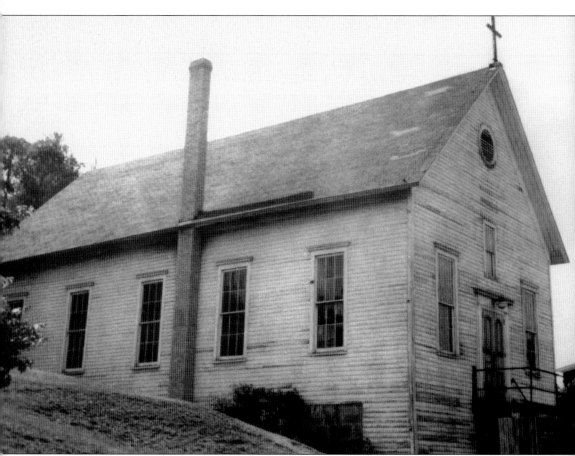

St. James in Petrolia, Butler County, was founded in 1874, an outcome of the booming oil industry of the 1860s and 1870s. Given that Petrolia did not have a significant Catholic population, St. James was never assigned a resident pastor. The church was always a mission of another church in a nearby community, including Brady's Bend, Parker, and Chicora. The church was razed in 1968 when the parish was merged with Mater Dolorosa in Chicora. (Courtesy Diocesan Archives.)

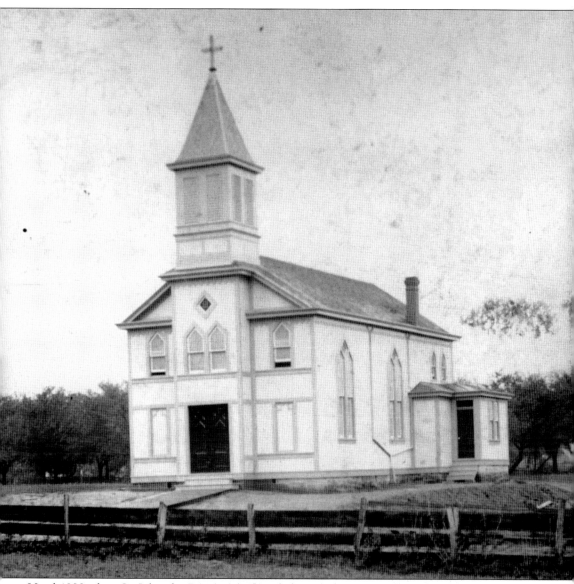

Until 1888 when St. John the Baptist was founded, Catholics residing in Monaca (then called Philipsburg) traveled to Rochester or Beaver to attend Mass. Population growth spurred by growing industry necessitated the building of a church in Monaca, although it remained a mission of St. Cecilia in Rochester until 1891. From 1900 until 1907, St. John the Baptist again became a mission church, this time of SS. Peter and Paul in Beaver. A resident pastor was assigned in 1907. (Courtesy Diocesan Archives.)

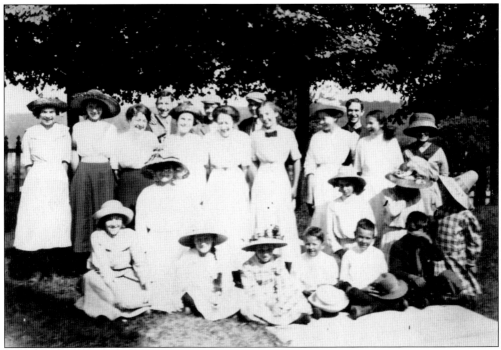

The Young Ladies Sodality of St. John the Baptist took a moment from the festivities of an early-1900s picnic to gather for this photograph. The majority of ethnic churches sponsored a sodality, which provided activities for the young women of the parish. (Courtesy Diocesan Archives.)

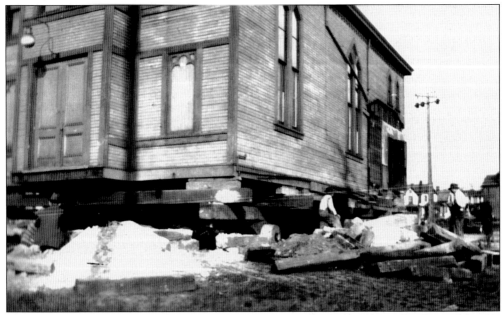

In the late 1890s, St. John the Baptist was moved to a new location. The technology of the day was not much different than that of today, although the workmen did not have the advantage of modern vehicles to carry and pull the load. (Courtesy Diocesan Archives.)

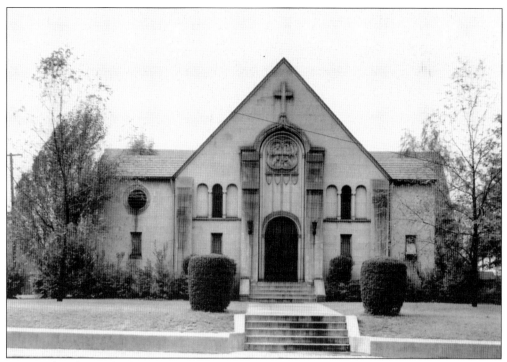

A new church was built and dedicated in 1913 to accommodate the growing population. It also proved to be inadequate, and a third St. John the Baptist was built and dedicated in 1932. (Courtesy Diocesan Archives.)

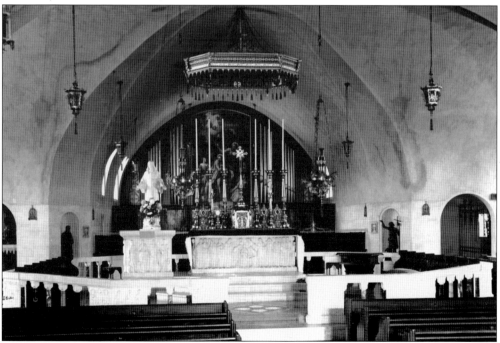

This c. 1930s image is of the main altar of St. John the Baptist as well as the magnificent marble Communion rail, which had been carved by skilled artisans. (Courtesy Diocesan Archives.)

The Communion rail rests outside the new St. John the Baptist, awaiting final preparations for installation. (Courtesy Diocesan Archives.)

The origin of St. John, Coyleville, can be traced to the arrival of Irish immigrants in Clearfield Township in 1798. Coylesville itself was not founded until 1830; St. John was dedicated in 1854 but did not receive a resident pastor until 1855. Prior to the building of the church, local Catholics rarely saw a priest. Once St. Patrick in Sugar Creek was established, a priest would travel to Coylesville once a month to say Mass in a private home. (Courtesy Diocesan Archives.)

Over the years, the original building had been remodeled and renovated. In 1877, the 156-foot tower was added, and in 1895, the roof was rebuilt and the altars were installed. (Courtesy Diocesan Archives.)

St. Joseph in New Brighton, Beaver County, was founded during the Civil War. In 1862, a priest from SS. Peter and Paul in Beaver visited New Brighton and celebrated Mass in a private home. Two years later, Bishop Michael Domenec visited and authorized the purchase of an old United Presbyterian church, which was then renovated and dedicated in 1863. The faith community of St. Joseph survived both the economic depression that swept the county in the 1870s and several fires that resulted in either total rebuilding of or significant renovation to the church. (Courtesy Diocesan Archives.)

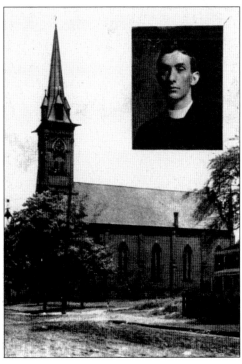

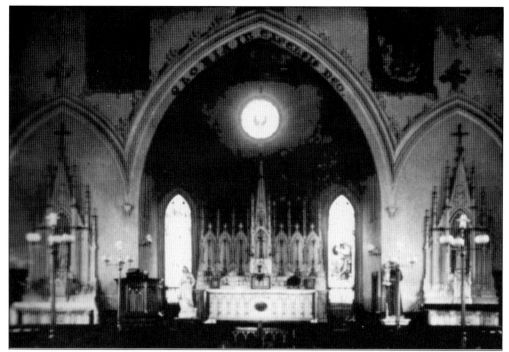

This image shows the interior of St. Joseph in 1885, the year the church was dedicated. Because of the economic depression of the 1870s, it was almost a decade before this second St. Joseph could be completed. (Courtesy Diocesan Archives.)

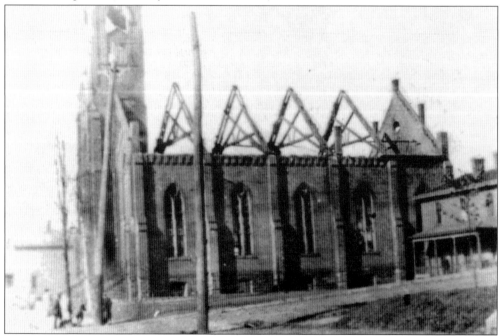

Less than 20 years later, in 1911, St. Joseph was struck by a devastating fire that destroyed the roof and steeple, leaving only the four walls and the base of the tower. Enough remained, however, to rebuild. (Courtesy Diocesan Archives.)

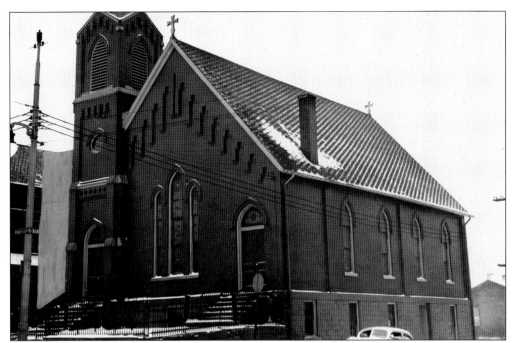

St. Ladislaus in Beaver Falls, Beaver County, was founded in 1923 as a Hungarian ethnic parish. The immigrant Hungarians in the area possessed as strong desire to worship in their native language. In 1924, the congregation purchased the old First Reformed Presbyterian Church, which had been built in 1878. (Courtesy Diocesan Archives.)

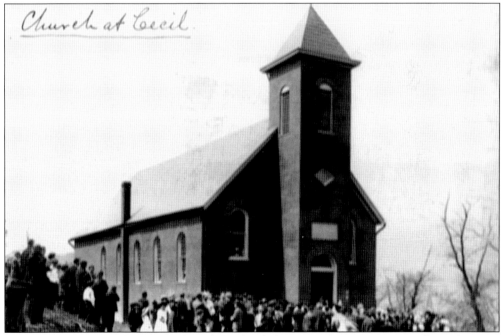

Church at Cecil.

On May 1, 1910, parishioners gathered for the dedication of St. Mary in Cecil, Washington County. The church served the faith community until the early 1960s, when it was razed to make room for a larger church. (Courtesy Diocesan Archives.)

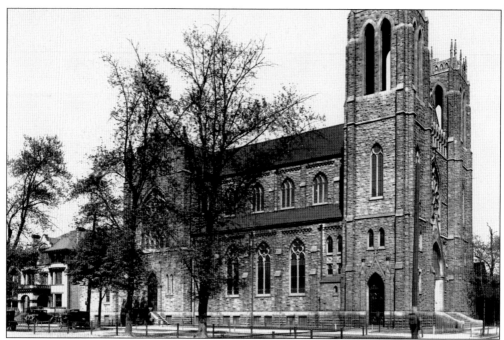

The expansion of heavy industry in the mid-1800s in Lawrence County attracted many looking for well-paying jobs. Prior to that, the few Catholics living in the area worshipped in a small, frame church in New Castle as a mission to SS. Peter and Paul in Beaver. Once again, population growth necessitated a larger church, and in 1927, the third St. Mary church was completed and dedicated. (Courtesy Diocesan Archives.)

In 1939, it became evident to the pastor of St. Gregory in Zelienople that a parish was needed in Evans City, Butler County, to serve the growing number of people in that community. A vacant Methodist Episcopal church was purchased and renovated for use as a parish church, and St. Matthias was dedicated on May 30, 1939. The church remained a mission of St. Gregory's until 1946, when a resident pastor was assigned. In 1968, the church was renovated and enlarged. (Courtesy Diocesan Archives.)

The origin of St. Michael in Avella, Washington County, can be traced to the creation of the Missionary Confraternity of Christian Doctrine in 1908. This organization provided catechetical instruction to communities too small to support a parish. The mission was established in Avella in 1909, and priests from the Pittsburgh Apostolate brought Mass to these small communities, sometimes celebrated in commercial buildings or theaters. In 1916, the bishop authorized a collection for the building fund to construct a church in Avella. The church was dedicated in 1917; however, Mass was celebrated in the basement until the upper level was completed in 1925. (Courtesy Diocesan Archives.)

School is out for the day, and the children of St. Michael in Avella seem eager to gambol in the newly fallen snow. (Courtesy Diocesan Archives.)

St. Peter, founded in 1821, was the first Catholic parish in Butler County. Its origin can be traced to the influx of Irish immigrants to the area beginning in 1795. For more than a decade, local Catholics were dependent upon traveling missionaries or priests passing through the area on their way to other destinations. By 1921, the Catholic population had grown sufficiently to warrant their own church, and St. Michael was built and dedicated in 1849. However, a growing German population began settling in the area, and soon a conflict arose between the two ethnicities, each wanting Mass to be celebrated in their own native language. Bishop Michael O'Connor intervened and assigned a pastor who could speak both languages. (Courtesy Diocesan Archives.)

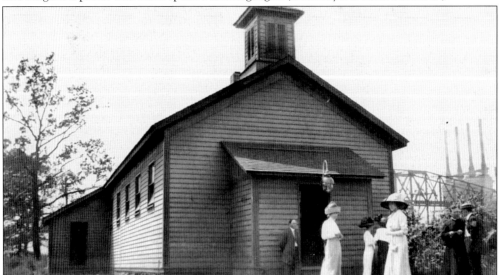

Both the community of Midland, Beaver County, and Presentation of the Blessed Virgin Mary church can trace their origins to the building of Midland Steel Company in 1906. The first Mass in Midland was celebrated in the dining room of the Orchard Hotel on December 16, 1906. In 1907, an old school building was purchased and converted into a church. By 1912, the parish was formally established. Note the smokestacks from the Midland Steel plant in the background. (Courtesy Diocesan Archives.)

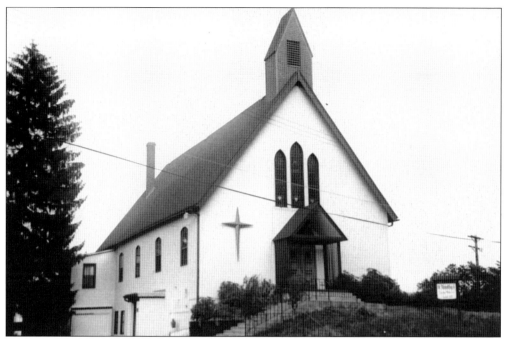

In 1918, a request was made to the Pittsburgh Confraternity of Christian Doctrine to send a priest to celebrate Mass in Indianola, Allegheny County. Prior to that, Catholics traveled six miles to the nearest church to attend Mass. Work began on a church building, and St. Timothy was dedicated in 1920. The parish served until 1991, when the dwindling population required a consolidation with St. Francis of Assisi in Harmarville. (Courtesy Diocesan Archives.)

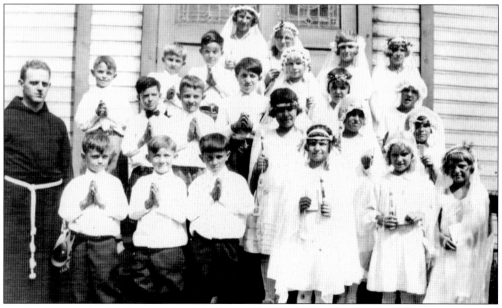

August 3, 1930, was the day the schoolchildren of St. Timothy made their First Holy Communion. After much preparation and study, this small group of Catholics was sent into the world to be good stewards of their faith and to hand down this tradition to the generation that followed. (Courtesy Diocesan Archives.)

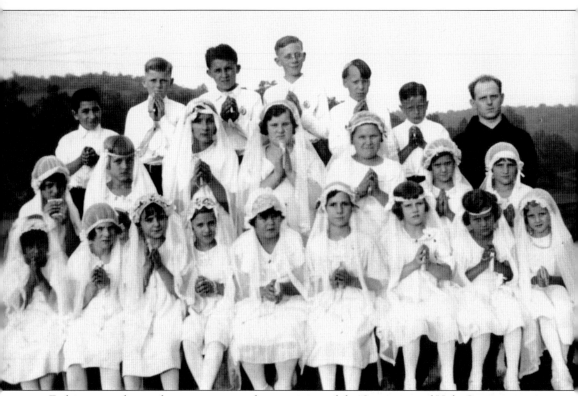

Fashion may change from year to year, but receiving of the Sacrament of Holy Communion is an ageless tradition of the church. On July 31, 1934, this group of youngsters from St. Timothy shared in the body and blood of Christ. (Courtesy Diocesan Archives.)

Four

THE CHURCH
IN COMMUNITY

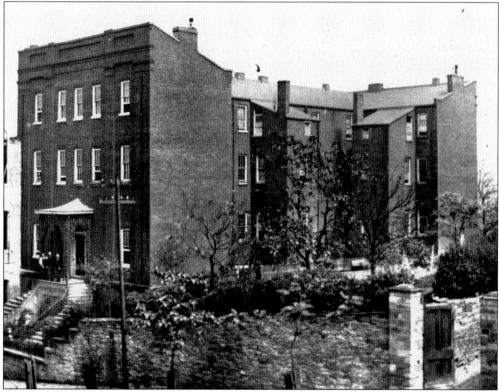

The Mercy Hospital of Pittsburgh was founded in 1847 by the Sisters of Mercy as the first permanent hospital in Western Pennsylvania. A special emphasis was placed on caring for the needs of the underserved. This 1848 view is of the original building on Stevenson Street. (Courtesy Diocesan Archives.)

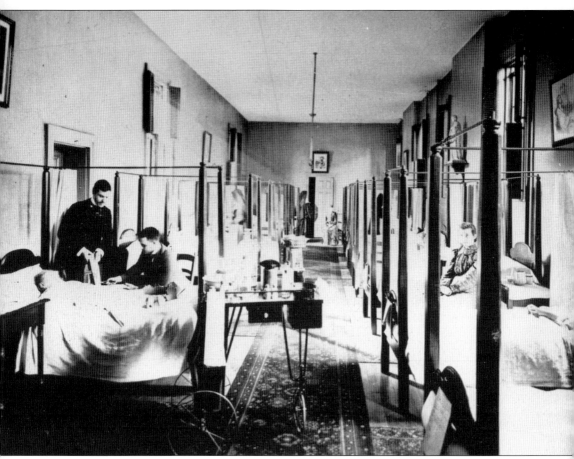

The women's ward was built in 1848. After renovation in 1947, it became the physicians' dining room. The Sisters of Mercy cared for the poor and particularly those suffering from the epidemics and influenza that struck Pittsburgh in the late 1880s and early 1900s. (Courtesy Diocesan Archives.)

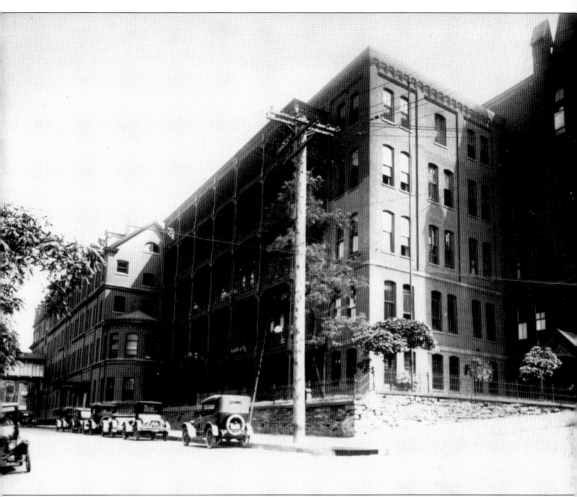

This is a view of the west wing that was added in 1882. The Mercy Hospital served not only Catholics, but all who were in need of care. (Courtesy Diocesan Archives.)

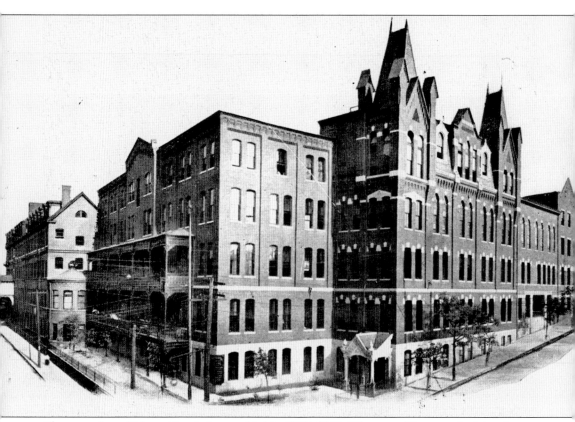

The east wing of Mercy Hospital was added in 1902–1903. (Courtesy Diocesan Archives.)

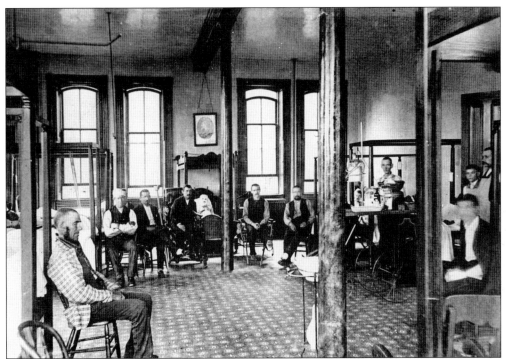

The old marine ward was built in 1894. The Sisters of Mercy cared for many veterans of the Civil War. (Courtesy Diocesan Archives.)

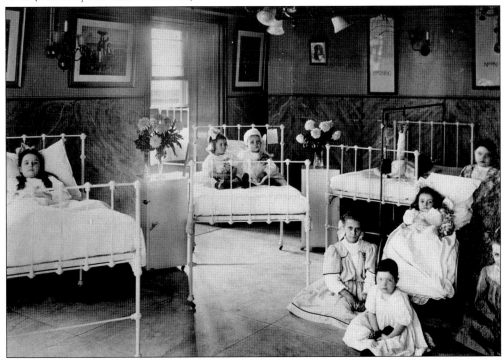

This 1905 photograph shows the fifth-floor girls' ward in the East Wing of Mercy Hospital. (Courtesy Diocesan Archives.)

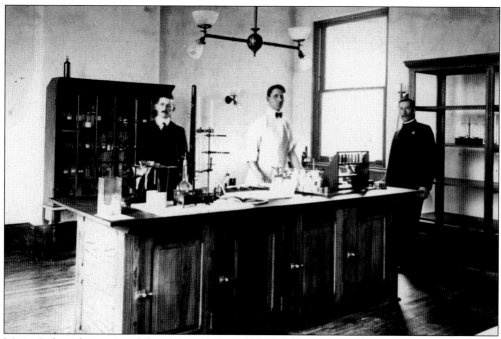

Magee Lab, with its state-of-the-art equipment in 1900, demonstrates that the Sisters of Mercy were diligent in their studies and kept abreast of new technology. (Courtesy Diocesan Archives.)

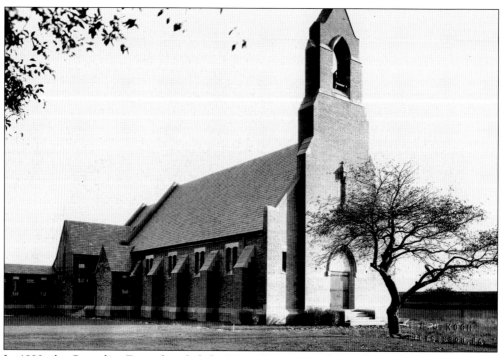

In 1899, the Capuchin Friars founded the Toner Institute and Seraphic Home for Boys. They would conduct retreats in the friary and played an important role in providing an education and life skills training for troubled boys of the diocese. (Courtesy Diocesan Archives.)

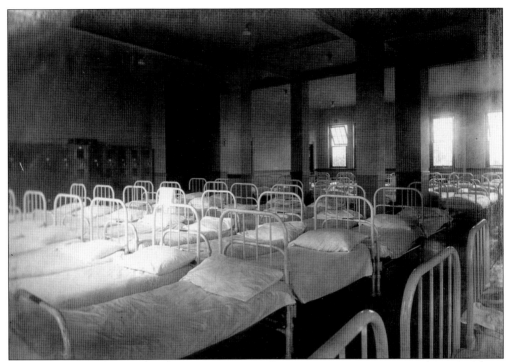

This is a section of the junior boys' dormitory. In the back of the room are steel lockers. On the back ends of the bed are brass plates carrying the inscription of the donor's name. (Courtesy Diocesan Archives.)

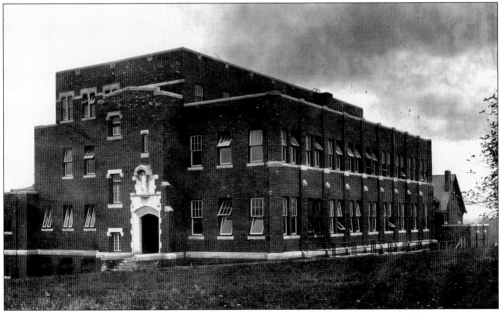

This is a view of the east front entrance of the main building. The statue above the door represents each boy's guardian angel. Toner Institute was named for Dr. James L. Toner of Westmoreland County, who provided in his will a fund to establish a home for boys from broken or disrupted homes. (Courtesy Diocesan Archives.)

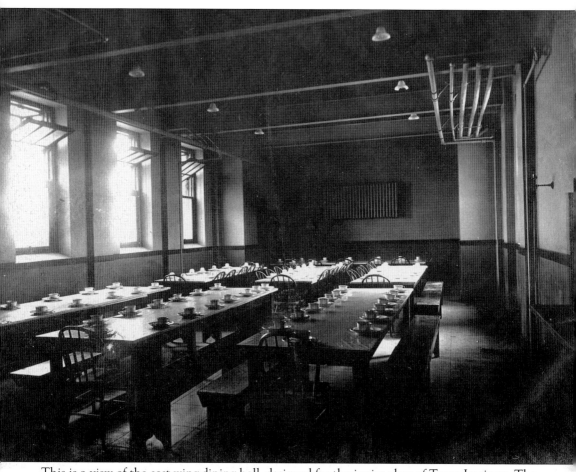

This is a view of the east wing dining hall, designed for the junior class of Toner Institute. The tables are set for breakfast. (Courtesy Diocesan Archives.)

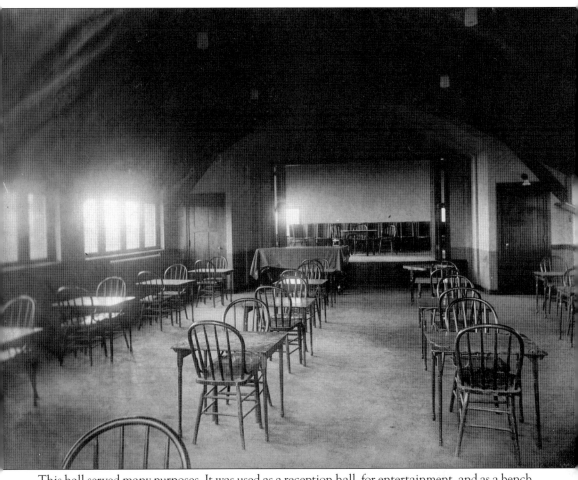

This hall served many purposes. It was used as a reception hall, for entertainment, and as a bench room for mechanical training. Below this hall is the gymnasium. (Courtesy Diocesan Archives.)

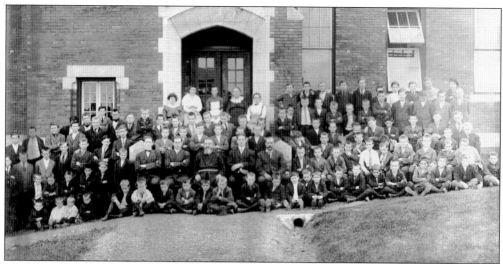

The faculty, staff, and boys of the Seraphic Home pose for a picture in October 1915. The boys, of various age groups, are neatly dressed in suits. (Courtesy Diocesan Archives.)

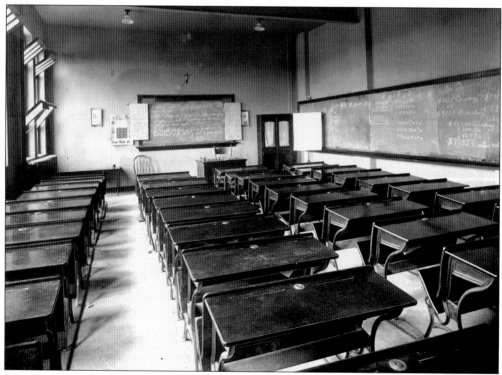

This is one of many classrooms in the building. The blackboard at the front of the room has been prepared for a math lesson. One boy of note who may have attended class here was Francis Joseph Unitas, father of professional quarterback Johnny Unitas. When his mother died and his father could not cope, Francis was dispatched with his siblings, twin brothers, to Toner Institute. At the age of 16, the maximum age for a resident, Francis Unitas left the institute, with two shirts wrapped around an old baseball glove, and headed for the coal mines of West Virginia. (Courtesy Diocesan Archives.)

The St. Anthony Village Orphanage was founded in 1921 by Fr. Boniventure Piscopo under the auspices of the Missionary Zelatrices of the Sacred Heart and the Diocese of Pittsburgh. The original site of the institution was a farmhouse on Hulton Road in Oakmont, shown in this c. 1925 image. (Courtesy Diocesan Archives.)

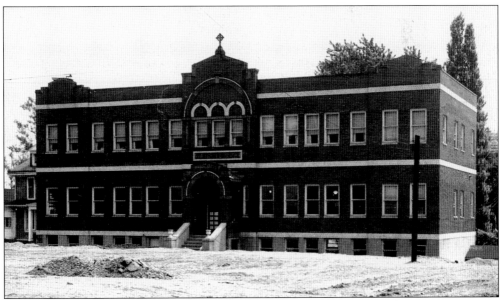

When founded, the orphanage served children from Italian-language parishes. It soon outgrew its original building, and new construction was begun in the late 1920s. The new building, pictured in this c. 1932 image, illustrates the rapid growth. (Courtesy Diocesan Archives.)

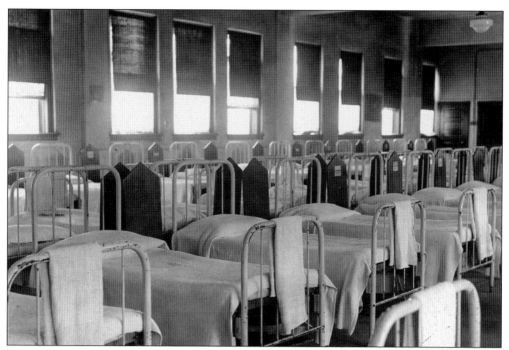

To accommodate the rapid growth of the institution, an expanded boys' dormitory was included in the new structure. This c. 1935 image shows neat rows of beds and linen and spotless floors. (Courtesy Diocesan Archives.)

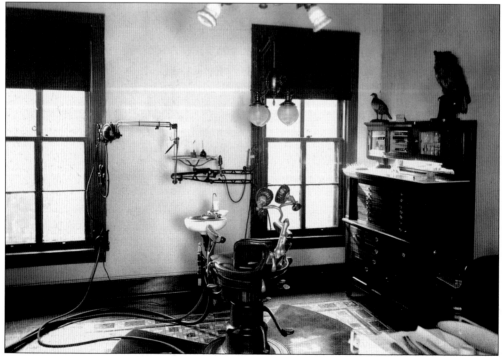

A state-of-the-art dental clinic was built in 1932. Children were given excellent medical care at St. Anthony Village Orphanage. (Courtesy Diocesan Archives.)

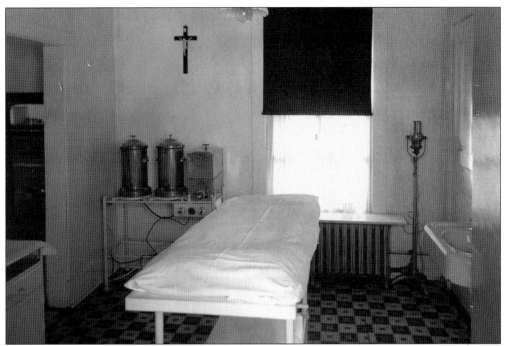

A state-of-the-art medical clinic was also built in 1932. Although it looks sparse by today's standards, the residents of St. Anthony Village Orphanage were given the best care possible. (Courtesy Diocesan Archives.)

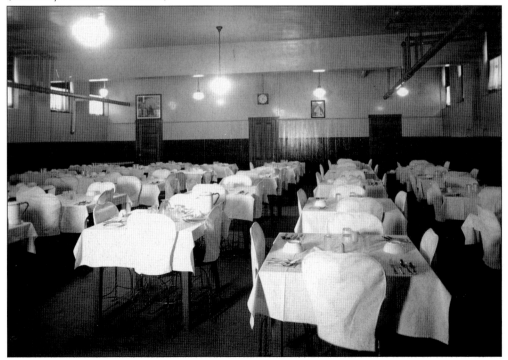

The dining hall is set for dinner. Children were fed three nutritious meals a day and were encouraged to exercise. (Courtesy Diocesan Archives.)

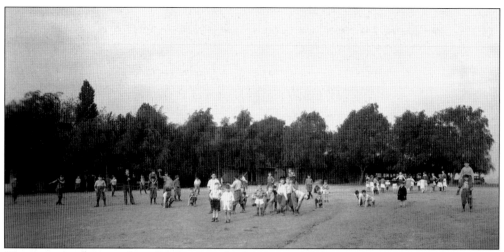

That exercise was gained on the playground, where several different events seem to be occurring simultaneously. (Courtesy Diocesan Archives.)

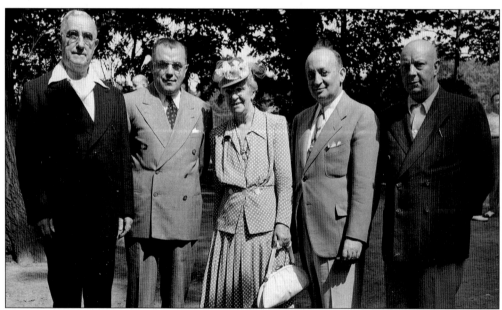

During the fresh air movement of the 1930s, attempts were made to provide opportunities for recreation for children living in industrialized cities. Epiphany Parish in Pittsburgh's uptown section sponsored a camp in rural Warrendale, just north of the city. From left to right, Fr. Lawrence O'Connell, pastor of Epiphany and after whom the camp was named; Henry Kalmine, under whose direction the camp flourished; Mrs. J. P. Harris, wife of the owner of the Harris Theater chain; M. A. Silver, Warner Brothers zone chief; and Joe Hiller, booker, pause from the festivities during the dedication ceremonies for Kalmine Recreation Hall in 1939. (Courtesy Diocesan Archives.)

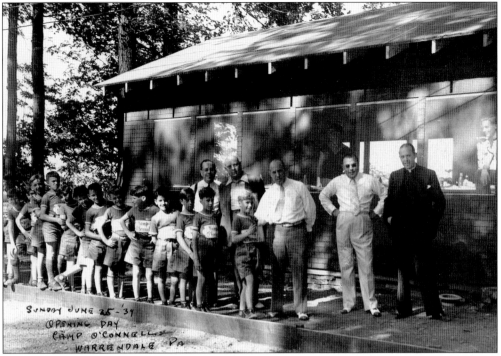

Sunday, June 25, 1939, was opening day of Camp O'Connell. Initially this was a camp for boys; eventually, however, it was opened up to girls. (Courtesy Diocesan Archives.)

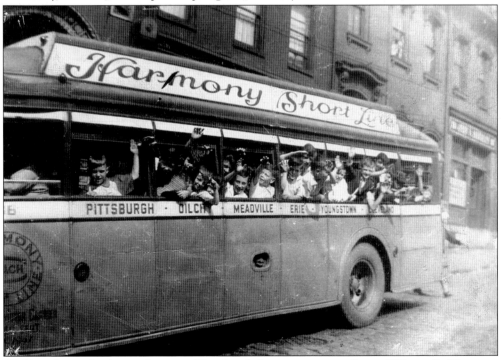

Children leave the dirt and grime of Pittsburgh for a vacation to Camp O'Connell. (Courtesy Diocesan Archives.)

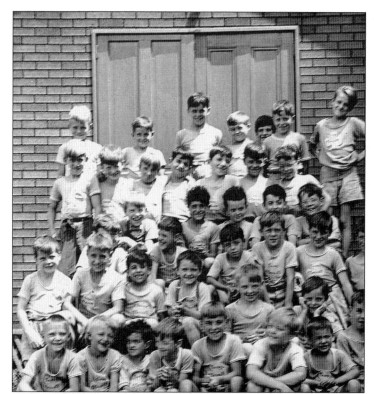

This undated image shows a group shot of happy campers, delighted to be away from the noise, crime, and pollution of the city. (Courtesy Diocesan Archives.)

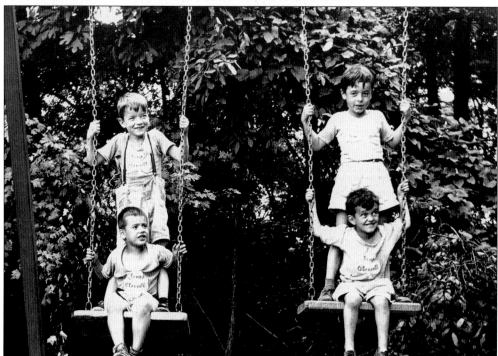

An opportunity for a tandem swing ride is relished by children who may have never even seen a swing. (Courtesy Diocesan Archives.)

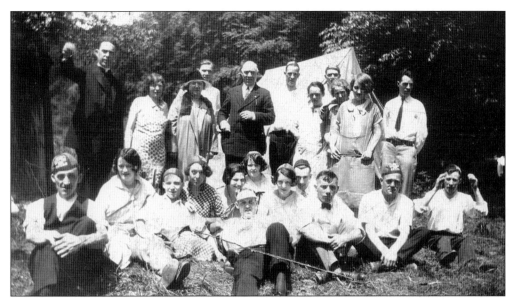

In this undated photograph, one can see the counselors who gave so generously of their time. (Courtesy Diocesan Archives.)

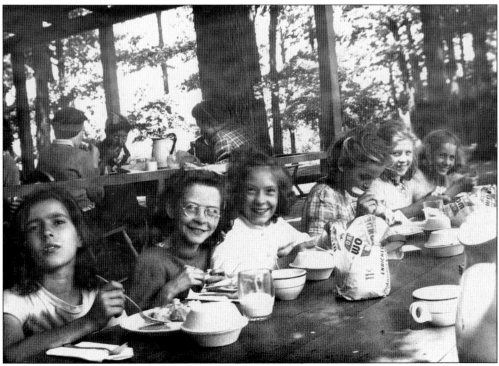

The girls take time for a healthy picnic lunch. Notice the Wonder Bread. (Courtesy Diocesan Archives.)

There are times when one cherishes solitude. Apparently this young lady is not a happy camper at the moment. (Courtesy Diocesan Archives.)

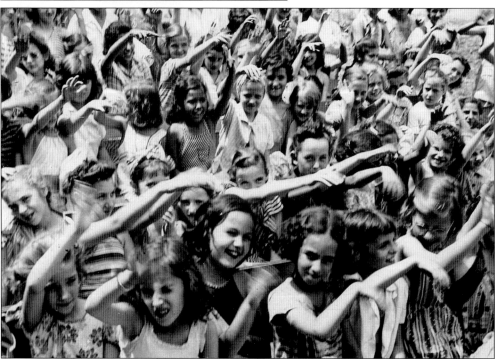

Music, sing-a-longs, and games were an important tool in teaching social skills at Camp O'Connell. (Courtesy Diocesan Archives.)

Five

FAITH TRADITION

St. Martin was founded in 1869 as a German parish in the West End. This class photograph, unfortunately, is undated. (Courtesy Diocesan Archives.)

This seventh-grade portrait is also from St. Martin Parish School in Pittsburgh's West End. The date, unfortunately, is illegible. (Courtesy Diocesan Archives.)

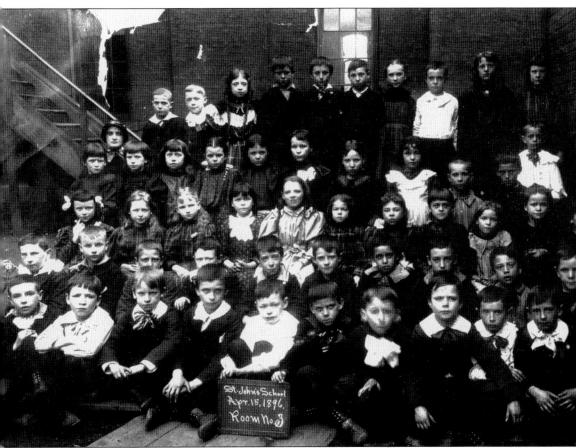

This 1896 eighth-grade graduation class is from St. John the Evangelist in Pittsburgh's South Side. The church was established in 1853 to serve the English-speaking Catholics living in what was then called Birmingham. (Courtesy Diocesan Archives.)

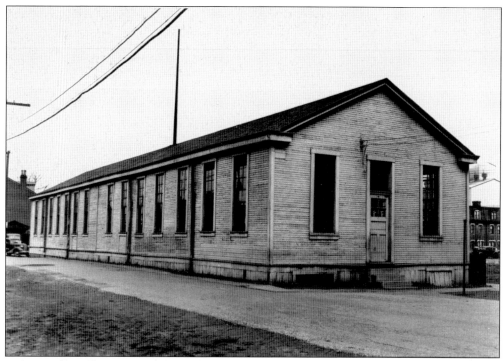

Holy Cross Parish was established on Pittsburgh's South Side in 1904. The parish's elementary school, seen here, was nicknamed the "Ark" and closed in 1950. (Courtesy Diocesan Archives.)

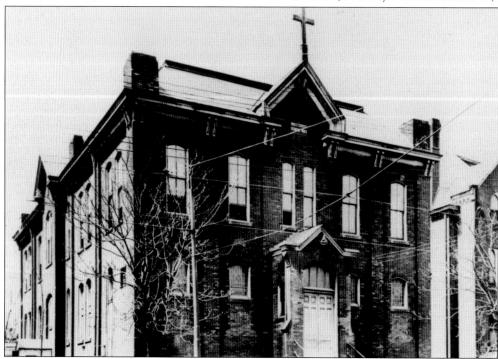

The Sisters of Charity taught in Holy Cross High School, in the South Side, from 1886 through 1950. This image shows the school in 1883. (Courtesy Diocesan Archives.)

St. William Parish was founded in 1906 in East Pittsburgh. May Crowning is a tradition shared by all parishes. This image shows, from left to right, Gladys Boyle; Betty O'Rourke, May Queen; and Marcella Wambaugh. (Courtesy Diocesan Archives.)

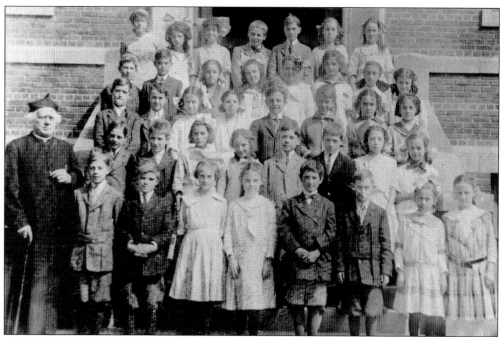

St. James in Wilkinsburg was founded in 1869 as an English-speaking parish. This 1914 graduation class includes Msgr. A. A. Lambing, pastor (at the left end of the first row); Mary Boggs (fifth from the left in the first row); and Rose Irene Boggs (right end of the first row). (Courtesy Diocesan Archives.)

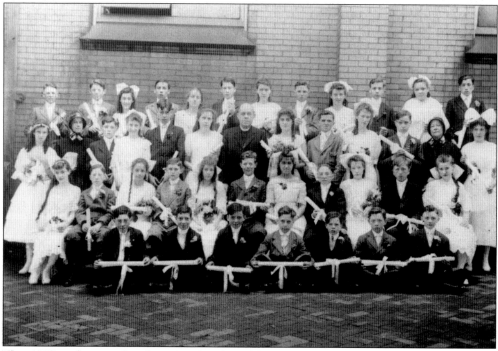

This 1915 graduating class from St. Mary Magdalene in Homestead includes Sr. Cyril Aaron, S.C. (left) and Sr. Beatrice Gority, S.C. (right). (Courtesy Diocesan Archives.)

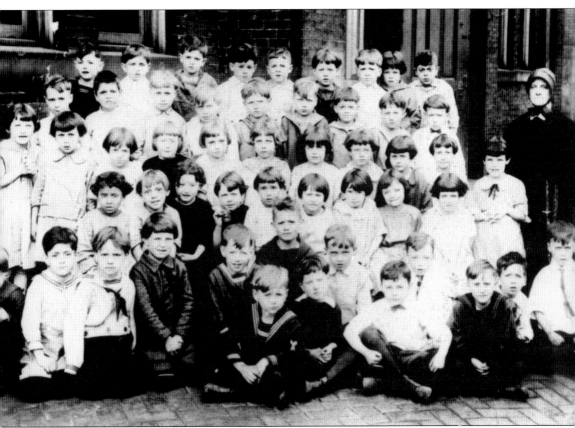

Sr. Mary Samuel Klingensmith, S.C., proudly poses with her 1925–1926 first-grade class of St. Mary Magdalene in Homestead. (Courtesy Diocesan Archives.)

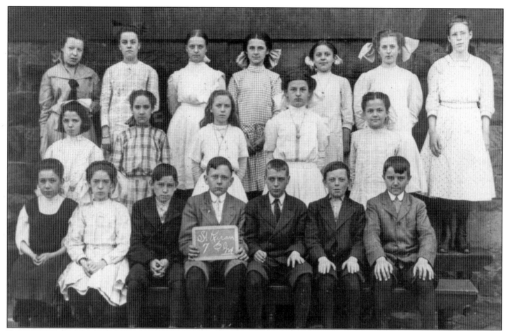

Sr. Ambrosia Timon's 1913 seventh-grade class at St. Kieran parish in Lawrenceville poses for their class picture. St. Kieran parish was established in 1887 as a result of the population increase, which came with the growth of industry after the Civil War. (Courtesy Diocesan Archives.)

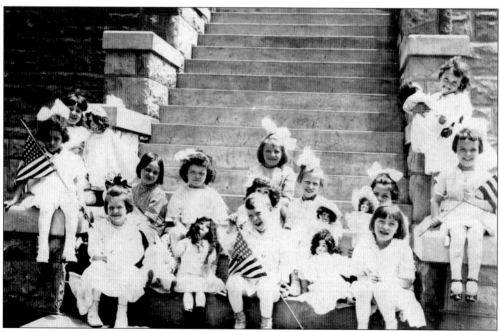

In 1918, the children of Epiphany church in Pittsburgh's uptown section were very proud to display their dolls in the school's annual doll show. (Courtesy Diocesan Archives.)

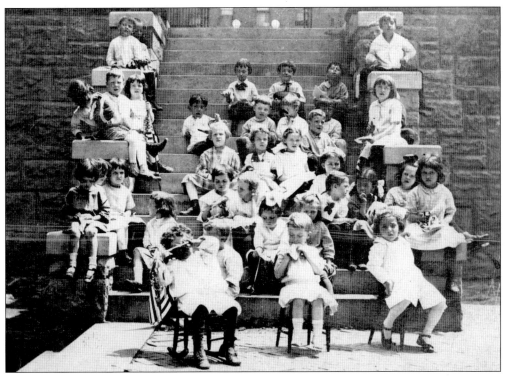

Even in 1916, it was difficult to get the kindergarten class of Epiphany church to sit still long enough to take a proper picture. (Courtesy Diocesan Archives.)

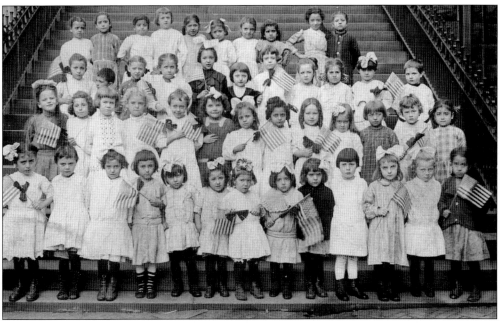

As was typical of most European immigrants of the 19th and 20th centuries, parents were proud that their children were Americans. The parents of Epiphany's 1912 first-grade class were no exception. (Courtesy Diocesan Archives.)

ACROSS AMERICA, PEOPLE ARE DISCOVERING SOMETHING WONDERFUL. *THEIR HERITAGE.*

Arcadia Publishing is the leading local history publisher in the United States. With more than 3,000 titles in print and hundreds of new titles released every year, Arcadia has extensive specialized experience chronicling the history of communities and celebrating America's hidden stories, bringing to life the people, places, and events from the past. To discover the history of other communities across the nation, please visit:

www.arcadiapublishing.com

Customized search tools allow you to find regional history books about the town where you grew up, the cities where your friends and family live, the town where your parents met, or even that retirement spot you've been dreaming about.